BOSTON
THROUGH TIME
Helen Shinn

AMBERLEY PUBLISHING

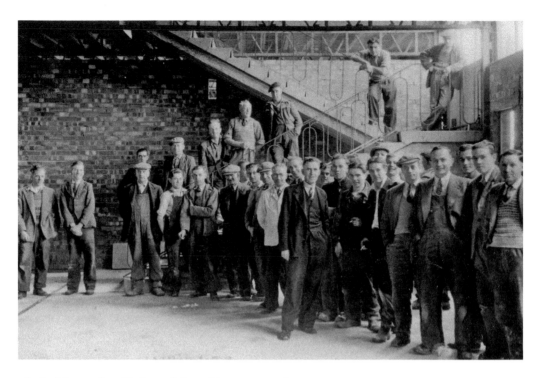

The builders and staff of Wright's Builders, Main Ridge, Boston, *c.* 1955.

Dedicated to past generations, most of whose names are missing from our history but whose hard work – through their labour, talents, and for those fortunate enough to possess or control enough of it, money – built and developed the town we treasure so much.

First published 2014

Amberley Publishing
The Hill, Stroud, Gloucestershire, GL5 4EP
www.amberley-books.com

Copyright © Helen Shinn, 2014

The right of Helen Shinn to be identified as the
Author of this work has been asserted in accordance with
the Copyrights, Designs and Patents Act 1988.

ISBN 978 1 4456 3675 7 (print)
ISBN 978 1 4456 3692 4 (ebook)

British Library Cataloguing in Publication Data.
A catalogue record for this book is available from the
British Library.

Typesetting by Amberley Publishing.
Printed in Great Britain.

Introduction

Boston has had a number of documented floods over the centuries, and the experiences of Bostonians on the night of 5 December 2013 are still fresh in the memory. With the disasters of 1978 and 1953 also within the living memory of the older generation, it is particularly ironic that the town probably owes its very existence to a great flood that occurred 1,000 years ago, in 1014. It was this inundation of seawater across the Fens that changed the course of the river towards the Haven at Skirbeck, rather than flowing further south into Bicker Haven and the mouth of the River Welland. Thus Skirbeck rose to importance as a port, and within the Parish of Skirbeck, where the tidal river was narrow enough to cross safely and close to a small church dedicated to Saint Botolph, a town soon grew, St Botolph's town, since the mid-sixteenth century known as Boston.

The town soon became the busiest port outside of London, exporting wool and raw materials and importing cloth, wine and luxury goods. As a member of the Hanseatic League and holding annual fairs, Boston was a lively and cosmopolitan place, home to wealthy English and Continental merchants and several religious friaries and guilds, all of whom contributed to the building of the mighty St Botolph's church (the Boston Stump), which towers over the town and surrounding Fens.

Bostonians have played a significant role in the discovery and settlement of far-off lands. As a centre of Puritanism, Boston lost hundreds of leading townsfolk from 1630 onwards, when they sailed to America in pursuit of religious freedom. They founded the City of Boston in Massachusetts, while later in the eighteenth century locals left to explore and assist in colonising new lands in the Pacific, some voluntarily as navigators and others transported against their will as convict labour.

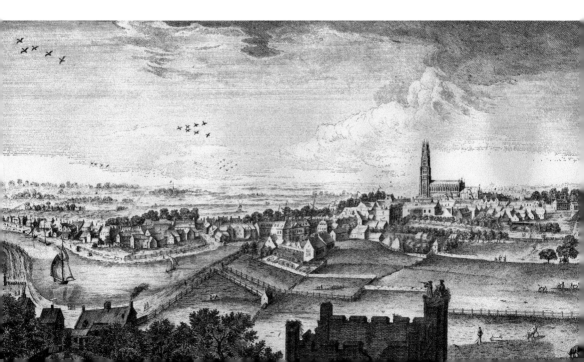

Dutch Engineers came over to work on the Fenland Drainage Schemes in the seventeenth and eighteenth centuries, forcing the self-sufficient fen-men, who had enjoyed the rich supply of fowl and fish for generations, to give way – but not without momentous riots – to the servitude of labouring for the new landowners of these rich and fertile soils. The new intensive agriculture fuelled a growth in the economy of Boston, and new housing and industry sprang up in the early and also the late nineteenth century. It has been said that Boston had more beerhouses and pubs than any other port in England, but at the same time Methodism and the Temperance Movement were strong in the town, inspiring a local girl to co-found The Salvation Army.

Boston was initially the home of the Great Northern Railway's locomotive works, who were a big employer. However, the coming of the railway to Boston was fiercely resisted by those involved in shipping, as inevitably they would feel the impact of this competition – shipping survived, however, and a new dock was built and other improvements were made in the 1880s. The fishing industry is still important, although a large fleet relocated away from the town in the 1930s.

Not many towns of Boston's size and population can boast of achievements such as these.

Helen S. Shinn
June 2014

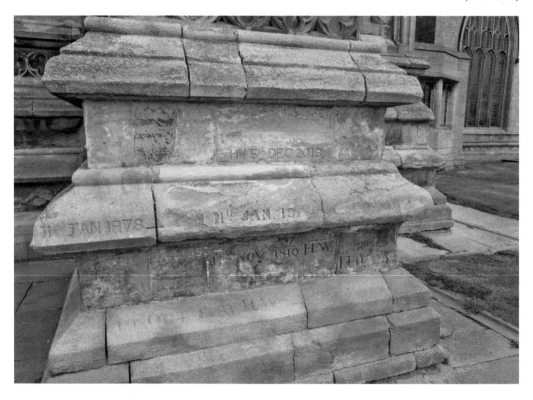

Markers at the base of Boston Stump serve as a reminder of the floods the town has endured over the last quarter of a millennium, recording high water levels since 1781.

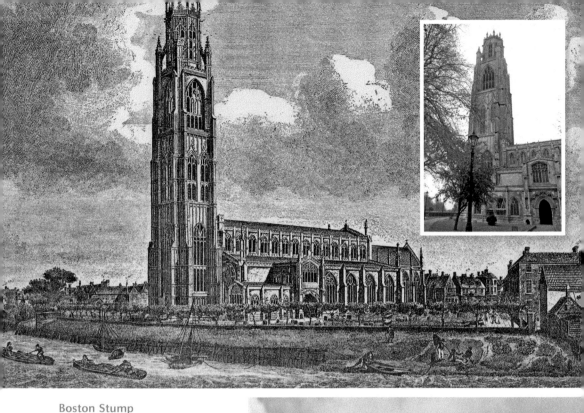

Boston Stump

Boston's famous landmark, the tower of St Botolph's, known as Boston Stump, stands 272 feet tall. It has an octagonal lantern, similar to the lantern at St Ouen's in Rouen and the one on the top of the Belfry in Bruges (another Hanseatic port), which incidentally is reached by 366 steps rather than Boston Stump's 365. Similarly, the tower bears a striking resemblance to the Cathedral of Our Lady in Antwerp, surely evidence of the influence of the Continental funding of the original construction of our church. The building of this church, on the site of a much smaller Norman one, was begun in 1309, and the foundations for the tower were dug first. However, no work on building the tower above ground level was done until the rest of the church was finished.

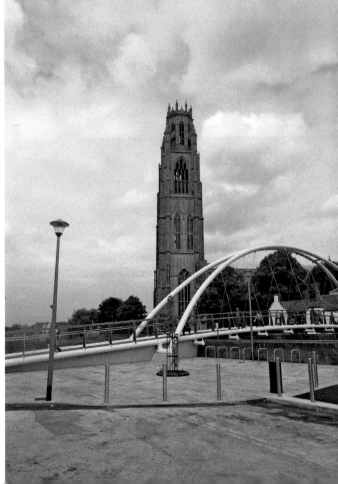

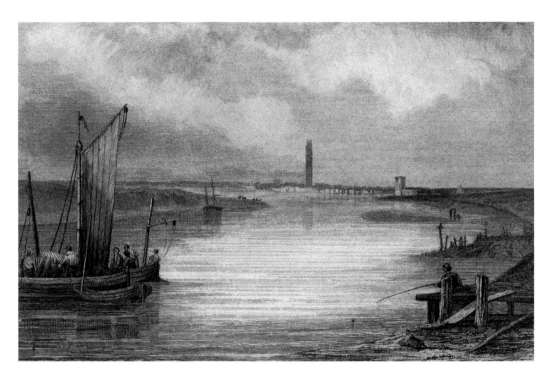

The Haven

Boston Stump has been used as a navigational aid for centuries, standing proud at a height of 272 feet. Its prominence is even more obvious in this 1831 view, long before the overhead gantry cranes or electricity pylons appeared on the skyline. In those days, the Haven was wider, shallower and meandered greatly, restricting the size of vessels that could reach the port, until in 1833 a New Cut was made between the Maud Foster and Hobhole drains, creating a shorter straighter route to The Wash. A Dutch vessel, *Elisabeth S*, is seen here departing for Liège in Belgium. The ship is owned by the Steenstra family, whose ships have been bringing in steel coils from Liège to Boston since 1979. Capt. Henk Steenstra and his cousin Capt. Klaas Bruins sail into Boston with their four sons very frequently, as do other members of the family on their ships. Four generations of the Steenstra-Bruins family have sailed between the Netherlands and Boston.

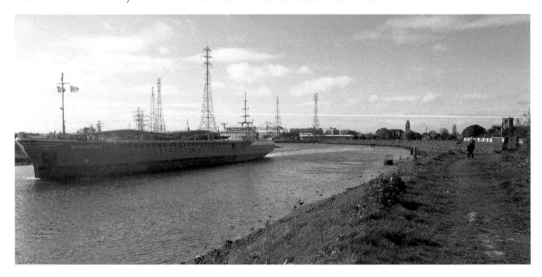

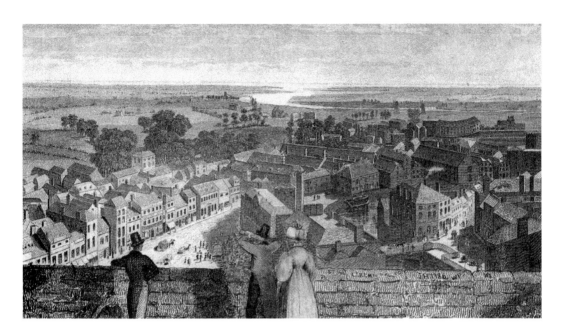

View from The Stump

Then, as now, glorious panoramic views are the worthwhile reward for climbing up all those stairs in our famously high parish church. It would have been a good vantage point for keeping a lookout at times of possible danger. In the 1830s, these finely dressed visitors could admire the recently enlarged and improved Market Place and the vessels in port. At that time, the ships came right up to the quays in the centre of town. Their eyes could trace the river as it passed by the many grain and wine warehouses and the newly built and gracefully curved South Terrace, and wound its way around fields and windmills, past distant Skirbeck village and out to sea. Once the new dock had been built in the 1880s, new industry and housing brought rapid growth and the green fields were lost forever.

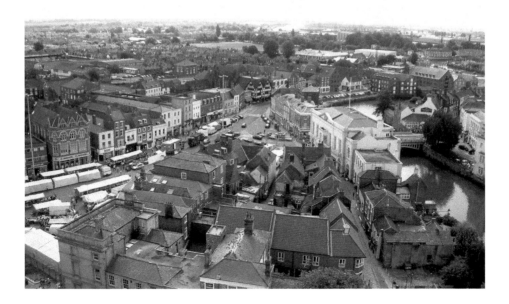

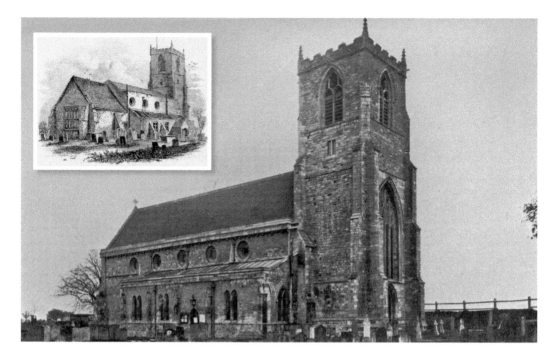

St Nicholas Church, Skirbeck

There has been a church on this site since before the Norman Conquest, indeed before Boston existed. It is believed that the present church was begun in around 1100, but it was inundated by a serious flood in 1286, which caused a great deal of destruction. The riverbank used to be much closer to the church than it is today. By the reign of Elizabeth I, the church had been reduced in size. The Norman chancel had gone, and part of the nave converted into a new one by removing the easternmost clerestory windows and shortening the aisles of the nave. The building had fallen into decay and went through a comprehensive restoration in the late nineteenth and early twentieth centuries, which significantly altered the nave and chancel in particular. This increased the capacity of the church at a time of huge population growth due to industrial developments, and the building of the new dock within the parish. The church has certainly had to adapt to the changes going on around it over the years.

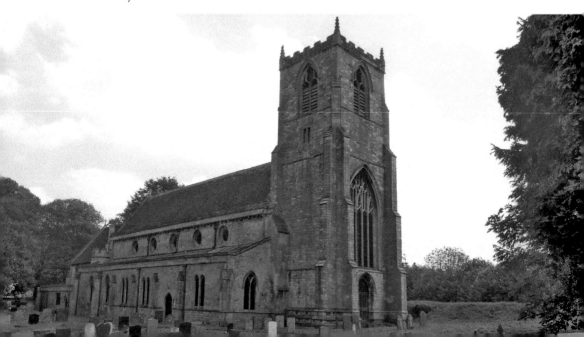

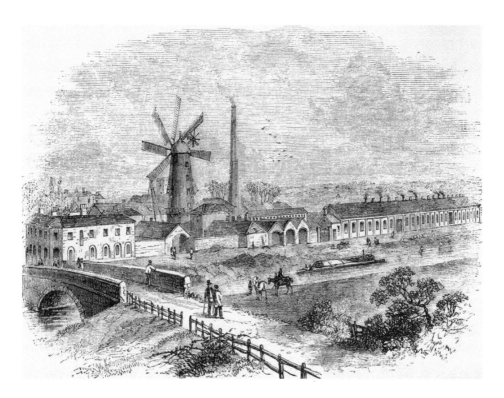

Mount Bridge, Skirbeck

Tuxford Mill, pictured here with St Nicholas church just visible to the left underneath the famed eight sails, was built in 1813. Tuxford & Sons had a worldwide reputation for their steam-powered thrashing machines, fountain pumps, windmill and other agricultural machinery. The firm exported across the British Empire, including to the West Indies and Australia. Mr William Wedd Tuxford and one of his investors, the pro-reform MP Mr John Wilks, made several attempts, at their own expense, to bore for water in Boston Market Place at a time when the town suffered from serious shortages of drinkable water. When the mill closed down, the site was bought by John Pocklington, who had also bought Heckington Mill, and he moved the eight sails there in 1890. There is nothing left of the foundry or the mill now, apart from the houses on the corner.

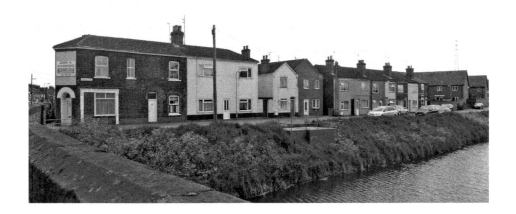

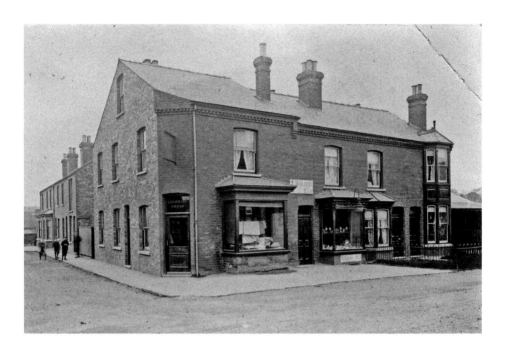

Skirbeck Road and Alfred Street

In the Victorian era, this end of Skirbeck Road, close to Mount Bridge, had a few grand Georgian houses belonging to some of Boston's shipping agents or brokers, and further along was where the Union Workhouse was situated. However, most of the smaller houses and the streets that lead off Skirbeck Road, like Alfred Street, were built between 1890 and 1905. Beyond Alfred Street was a small ironworks and the dock offices near the dock entrance. The large corner house and shop was probably occupied by Henry Pinner from the time it was built, and for many years after. Many of the local people living here in the 1900s were fishermen, dockers or workers in the local ironworks or timber yards. Girls and women were often employed in the local pea factories or the cigar factory, situated further up the Maud Foster Drain near Bargate End.

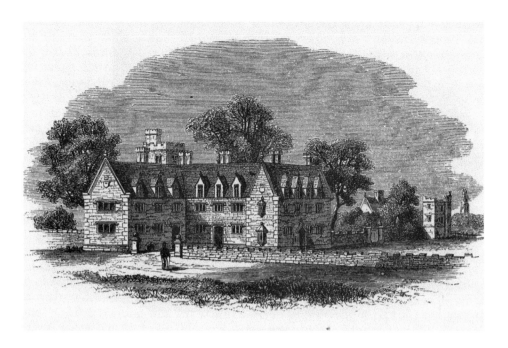

Hussey Tower

The lake has gone without a trace, and now forms part of the grammar school playing field. The remains of the tower are all that is left, but as the 1856 engraving reveals, there was once a great hall on the site. It was originally known as Benyngton Tower, having been built for Richard Benyington in around 1460. Lord Hussey, whose family inherited the residence, is famed for being found guilty of treason and executed following his unfortunate implication in the Lincolnshire Uprising in 1536, when hundreds of Lincolnshire men descended upon Lincoln Cathedral to protest against Church reforms in the reign of King Henry VIII.

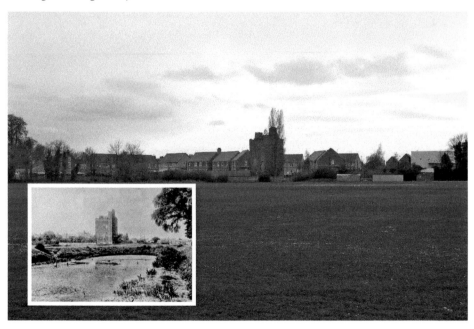

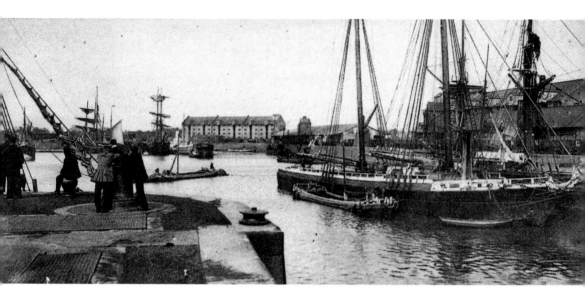

The Port of Boston

An 1881 Act of Parliament authorised the construction of the new dock, to be built by the Boston Corporation. The first sod was turned over by the Mayoress in a ceremony on 17 June 1882. It was a big occasion involving a procession from the town, with the Volunteer Militia marching and huge numbers of people lining the route. Perhaps the scale of the celebration was due to the fact that at first it had been proposed that the dock should be built at Freiston Shore rather than in the town. The dock was designed by Mr William Henry Wheeler, and the total cost of more than £100,000 was paid for by local ratepayers. Today, the dock is in private ownership, owned by the Victoria Group, and remains a thriving part of the town's economy, employing seventy people and handling 1 million tonnes of cargo and 450 ships per year. In the picture below, the dock gates are open as two ships have just departed with the *Lyn Ellis* (the pilots' vessel) following on a few minutes later.

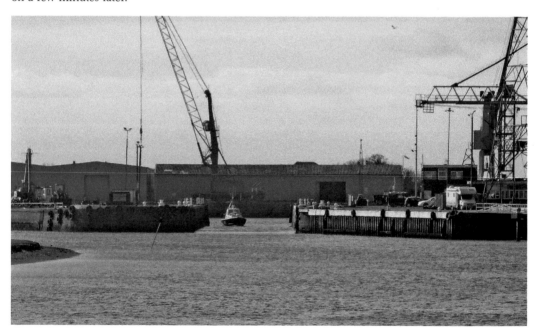

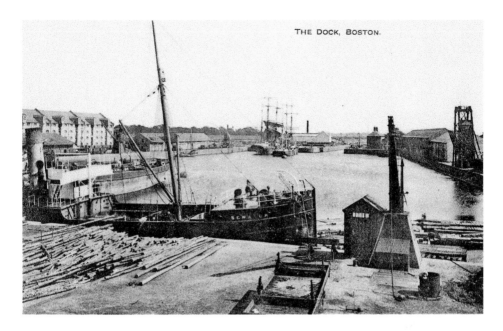

The Port of Boston

The Port of Boston has changed over the years, just as the ships have. As most ships were steam-powered, the coal hoist on the right would have hoisted up wagons of coal, lifting them up above the vessel, which was moored up alongside, tipping the load into the ship, and then returning the wagon back onto the tracks on the quay. Most of the old buildings have gone now, with modern warehouses replacing them on a site that was extended after the end of the Second World War. In the picture below, the *Sea Riss*, on the left, is being unloaded of her steel, which comes in from the near Continent, and will be forwarded by rail to the Birmingham area. On the right, the *Casablanca* is being unloaded of her paper, which has come in from Germany via Amsterdam. A large volume of timber is imported from Finland and Scandinavia for a factory very close to the port. The main exports are grain (wheat, barley and rapeseed), and also scrap steel and waste plastics.

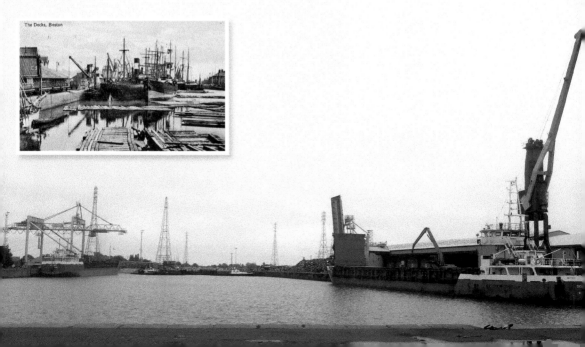

The Docks, Boston

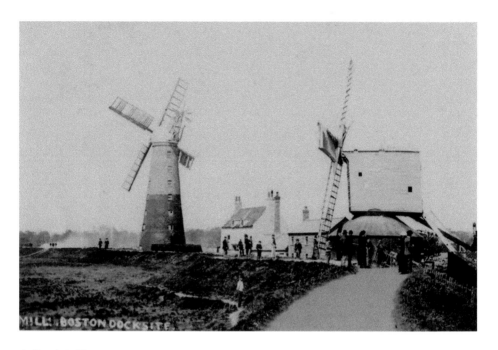

Gallow's Mills

Gallow's Mills were located just to the west of the outfall of the Maud Foster into the Haven, at the end of Poor House Lane, past the workhouse and surrounded by fields. The area was redeveloped when the dock was built in 1882–84. The first vessel to use the dock was the steamship *Myrtle* on 15 December 1884, bringing in cotton seed from Alexandria for Messrs Simonds & Son. Below, the Dutch-registered *Beaumaiden* is being unloaded of her cargo at the dock entrance on 17 April 2014. The scrap metal seen piled up here is taken for recycling in northern Spain.

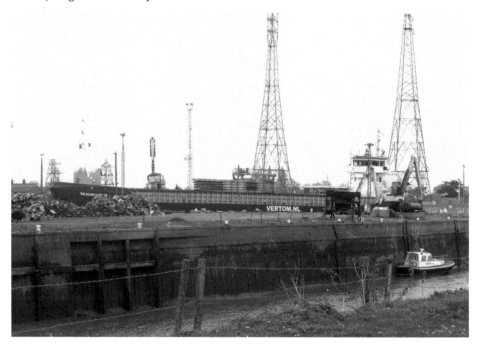

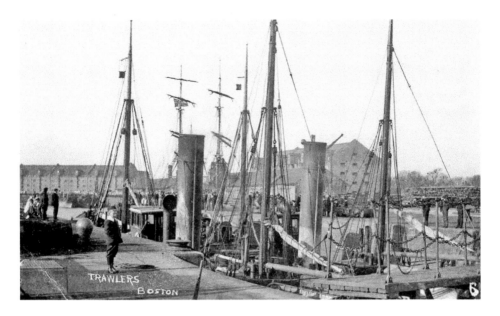

The Fishing Fleet

The Boston Deep Sea Fishing & Ice Company were founded in 1885, shortly after the opening of the new Boston Dock by Thomas Cheyney Garfit, of the well-known family-owned bank in Boston at that time. The company started out with a small number of fishing smacks and steam trawlers, but they expanded by buying up newly established rival fishing companies. The fishing industry employed a large number of people and built its own fish market, icehouses, workshops and offices. The company later relocated its entire fleet to Fleetwood in Lancashire, following a dispute with the local authority over the expense of trying to remove a sunken ship in the Haven that blocked all shipping movements into and out of the port. Today, shrimp and cockle fishing is important, and there are a significant number of trawlers, brightly coloured and seen here moored along the quayside next to London Road.

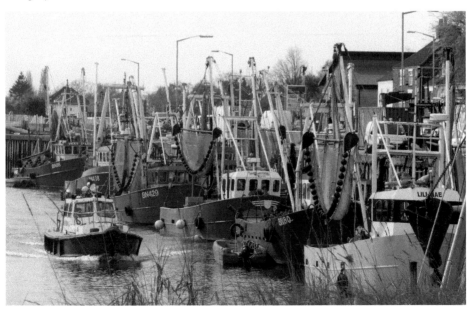

15

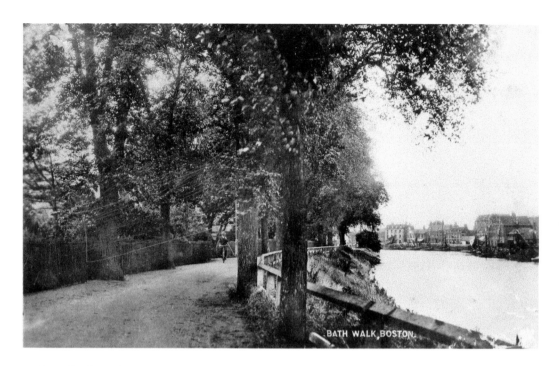

Bath Walk Along the Haven

Until the expansion of the docks after the Second World War, this was a pleasant riverside walk on the edge of the People's Park, which covered several acres of land. This park and public baths, consisting of two open-air lakes for swimming, were opened in August 1834. In the distance, some prominent houses on London Road can be seen. The tallest of these was once the home of George Bass, a surgeon in the British Navy famous for circumnavigating Van Diemen's Land (Tasmania), determining that it was an island and lending his name to the Bass Strait that separates it from Australia. The house adjacent to it on the left was the vicarage of St Thomas' church in Skirbeck Quarter. Sadly, both of historically significant buildings have fallen into decay over the last decade or so. In the modern view, work is being undertaken to rebuild the river's flood defences, work that had commenced before the December 2013 flood.

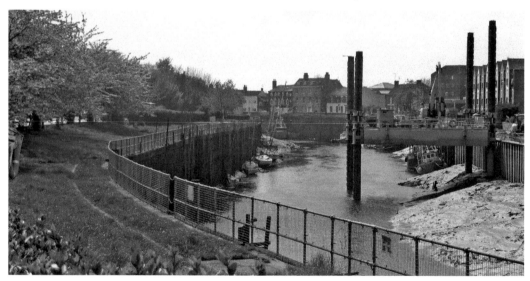

The Crown and Anchor, London Road
The public house pictured, at No. 20 London Road, Skirbeck Quarter, was the Crown & Anchor, which closed down and was demolished by Johnson's Seeds in the late 1960s so that a new entrance could be built to their Stells Lane factory. However, the original Crown & Anchor had been a large coaching inn at No. 16 after 1803, before which it had been a private house where George Bass, the celebrated navigator and naval surgeon had once lived. Today, all that remains is a commemorative plaque dedicated to George Bass and the Crown & Anchor sign, which had been cast at the Howden Iron Works at Witham Town near the Sluice Bridge, and had been fixed to the wall of the old pub.

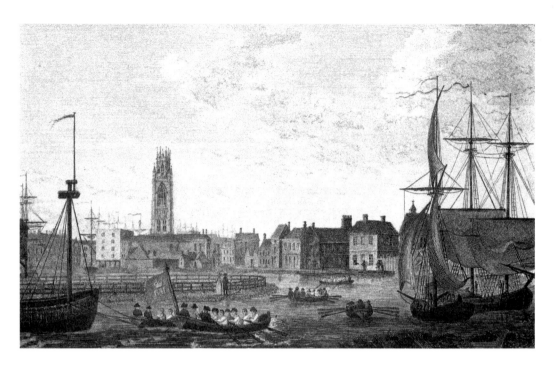

South End

In the days of the sailing ships, it was necessary for vessels to be guided in by a small rowing boat. The team of rowers were not actually tugging the ship, merely preventing it from being blown off course and hitting the banks of the meandering river as it made its way into the port. Before the Haven Bridge was built in 1964, there was a little ferry boat in operation between the end of Pulvertoft Lane and Skirbeck Road.

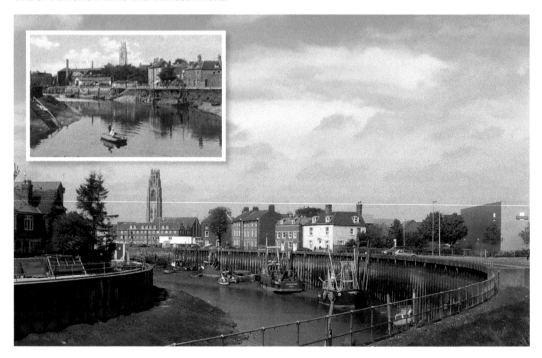

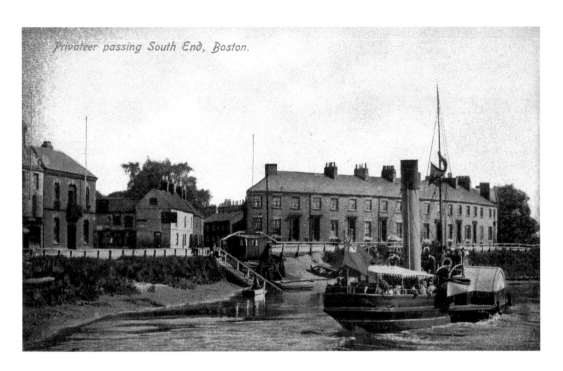

Privateer passing South End, Boston.

Boat Trips on the Haven

The *Privateer* was a steam-powered passenger vessel. Today, the *Boston Belle* (*inset*) makes regular passenger trips inland as well as heading out to The Wash and Fosdyke. The little ferry boat that went across the river at this point is a distant memory. The grand-looking crescent of Regency houses on South Terrace remain, as does the public house on the corner of South End and Skirbeck Road, although today it is a Portuguese bar. The road in the centre, St John's Road, still leads to the docks but the housing has gone.

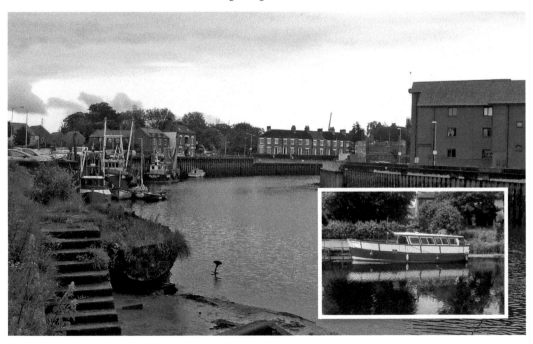

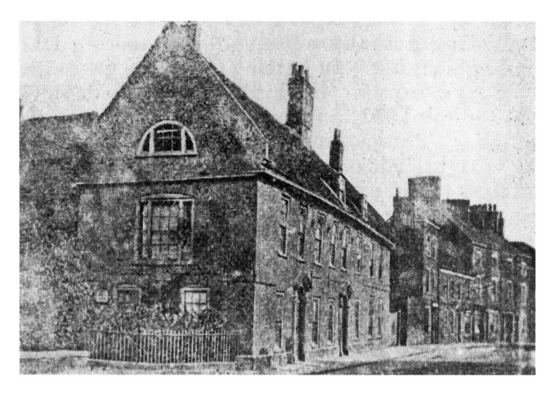

High Street

This large house was owned by William Garfit, who founded the first bank in Boston, situated further up High Street across the road at No. 116. At this point, the Old Hammond Beck flowed underneath the road into the Haven. The Hammond Beck was a river that marked the boundary between Boston and Skirbeck Quarter, but the water was later redirected, along with Redstone Gowt Drain, into the South Forty Foot Drain further south. The row of three-storey Georgian terraced houses further along the street remain, but inevitably Garfit's House was demolished to widen what, until the 1990s, was the main A16 trunk road to Spalding and the south.

The Plough, High Street

The Plough was situated on the corner of St Ann's Lane at No. 134 High Street. It was closed down in around 1960 and demolished. The licence for The Plough was granted before 1784, and following Queen Victoria's marriage in 1840, it was renamed The Prince Albert, although the pub reverted back to its original name following Prince Albert's death in 1861. In 2014, the site is temporarily being used as a base for the Environment Agency contractors, who are working on the flood defence work being carried out along the Haven. A new piled wall along the river's edge is being built, replacing an eighty-five-year-old wall that could no longer be relied on for flood protection.

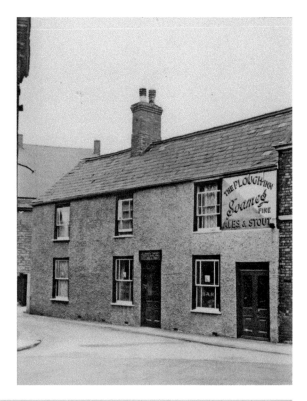

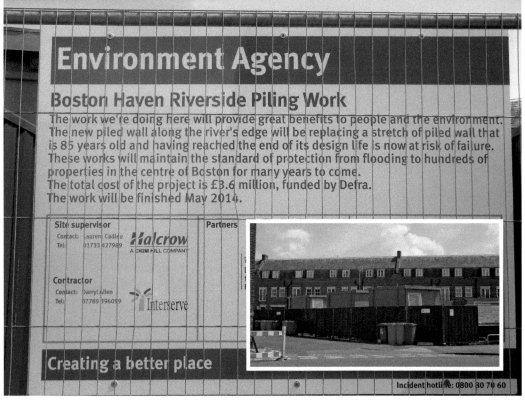

Environment Agency

Boston Haven Riverside Piling Work

The work we're doing here will provide great benefits to people and the environment. The new piled wall along the river's edge will be replacing a stretch of piled wall that is 85 years old and having reached the end of its design life is now at risk of failure. These works will maintain the standard of protection from flooding to hundreds of properties in the centre of Boston for many years to come.
The total cost of the project is £3.6 million, funded by Defra.
The work will be finished May 2014.

Site supervisor
Contact: Lauren Cadieu
Tel: 01733 427989

Halcrow
A CH2M HILL COMPANY

Partners

Contractor
Contact: Darryl Allen
Tel: 07789 396059

Interserve

Creating a better place

Incident hotline: 0800 30 70 60

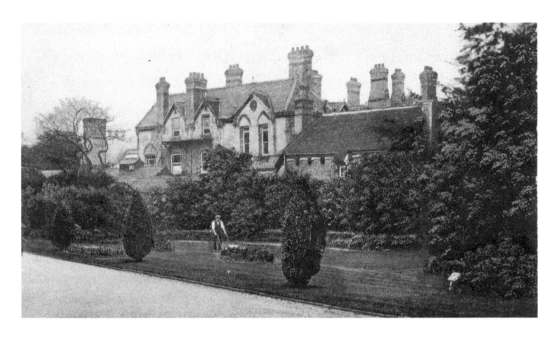

The Hospital

The hospital was next to the People's Park, also known as South End Park, a delightful retreat for townsfolk, which offered facilities for football, hockey and cricket. It also became the home for some relics from the old Lodswick House, formerly St George's Guildhall, after it was demolished in 1897. The purpose-built General Hospital, pictured above, was opened in 1874 to replace two small cottages in Irby Street that had been used as the town's infirmary. Before the creation of the National Health Service in 1948, admission to the hospital depended on a recommendation from a subscriber, in addition to a medical certificate, and a committee met once per week on a Monday morning to consider applications for admission. It was normal for adult patients to pay 5s per week for their upkeep, the rate being halved for children, and the wealthier were expected to contribute more. Cases of accident and emergency could be admitted at any time. The Pilgrim Hospital was opened in 1976, and is the second largest hospital in the county. It has undergone extensive redevelopment over recent years, with a state-of-the-art Intensive Care Unit and offers twenty-four A&E cover across the wider area, including the Lincolnshire Coast resorts and South Lincolnshire.

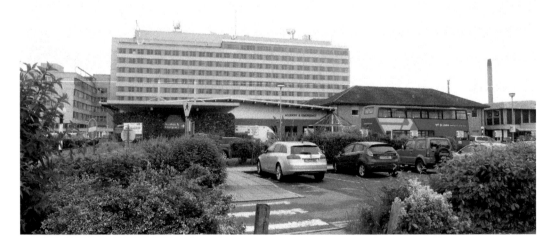

Ingelow House, South Square

This house was owned and lived in by one of Boston's first private bankers but it is his daughter, Jean Ingelow, who is best remembered. She was a poet and a children's author, having written *Mopsa the Fairy* among others. Probably her best known work is 'The High Tide on the Lincolnshire Coast', a poem about a devastating flood that hit the town in 1571. The name Ingelow lives on in the form of Ingelow Avenue on the Fenside Estate, but her home, which was later used as a girls' boarding school in the Victorian and Edwardian eras and survived a serious fire in 1908, was demolished in around 1960 to make way for the new Haven Bridge.

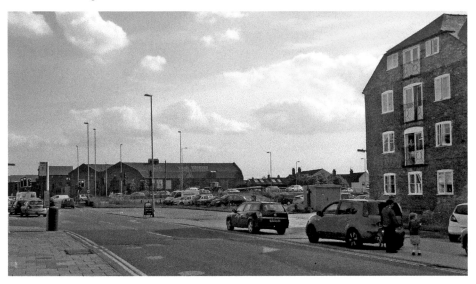

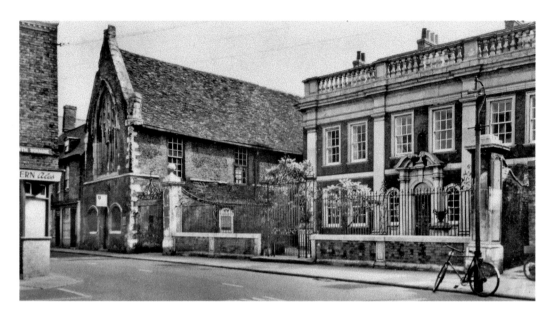

Guildhall and Fydell House, South Square

The guildhall was built for the Guild of St Mary's, and after the Reformation was handed over to the newly formed Corporation of Boston by Royal Charter, becoming the town hall until 1835 with a court house and cells (where the Pilgrim Fathers were famously held following their arrest for attempting to emigrate in 1607). It has been a place for civic hospitality but in contrast cheap, hot meals were also served up from its kitchens for townsfolk in both World Wars. It is now the town's museum and Tourist Information Office. Fydell House, next door, is a Queen Anne town house, built by Samuel Jackson in around 1706, but takes its name from the Fydell family, who lived there after 1726. Important visitors to the house have included Sir Joseph Banks, the highly regarded botanist who accompanied Captain Cook on some of his Pacific voyages, and Joseph Kennedy, father of US President J. F. Kennedy, in his capacity as ambassador to Great Britain. Just as important today are the many tourists and locals who visit to learn of its history.

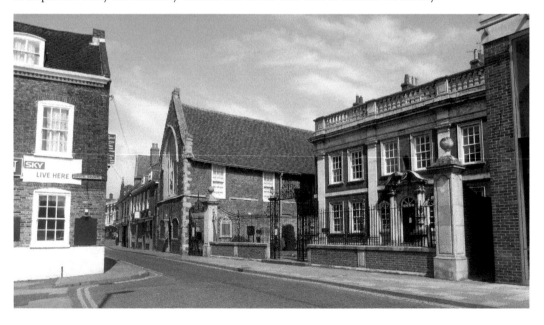

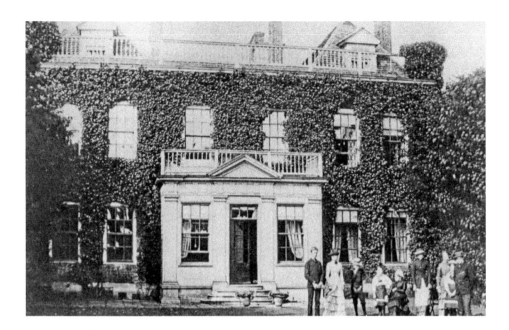

Fydell House, South Square

After the Fydell family left the town, they leased the house out to a series of tenants, and pictured above are Mrs Collins and her family and servants, who lived there when this photograph was taken in 1880. The house is significant to the town's historic links to Massachusetts and Australia, but nevertheless came close to being demolished to make way for an access road in 1933. It was saved by Canon A. M. Cook and the people of Boston who raised the funds needed to buy it. It has been held by the Boston Preservation Trust ever since, and both the house and its beautiful gardens are open to the public free of charge. They are kept in good order through the dedication and hard work of the manager James Forinton, housekeeper Abbi Coulam, and a small team of talented gardeners, some of whom are seen in the photograph below.

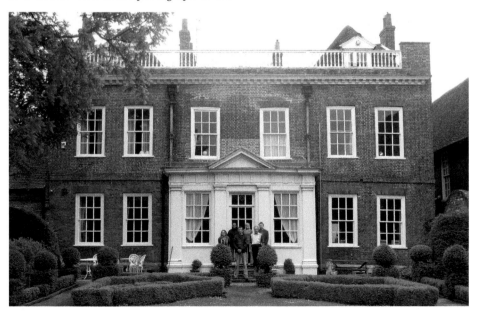

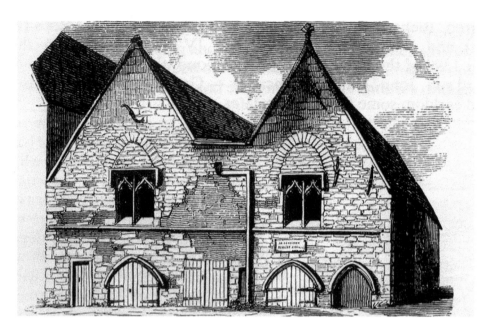

Gysor's or Jesar's Hall

This was the house of the de Gysor (sometimes spelt Jesar) family, probably originating from Gisour in Normandy, some of whom held the posts of Mayor of London, Sheriff of London or Constable of the Tower of London, in the thirteenth and fourteenth centuries, as well as being influential merchants and guild members in Boston. The hall was held as part of the Manor of Boston, in turn part of the Richmond Estates, and as such became the property of John of Gaunt, Duke of Lancaster, King of Castile (in Spain) and son of King Edward III. The building was where customs payments were made in respect of goods moving through the port, collected on behalf of the Earls of Richmond, including Henry Tudor (later King Henry VII). The Corporation of Boston sold the building to Mr Fydell in 1791 for £400 and an annual rent of one shilling. He demolished it in 1810, but reused the stone in the ground floor of his new granary, which later became a seed merchant's warehouse and is today a block of apartments.

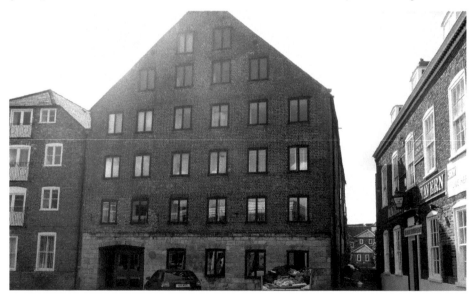

Blackfriars

This is the oldest building still standing in the town of Boston today, and was part of the Dominican Friary, built in the thirteenth century. The remaining part of the friary still standing was at the time used as the refectory, where the friars ate and hosted guests, including King Edward I, who paid the friary a visit in the late 1290s before holding court in Lincoln. By the nineteenth century, the building was used as a warehouse, but in the 1940s it was bought and preserved by the Boston Preservation Trust. It is now in use as the town's theatre and arts centre in the heart of Boston's cultural quarter.

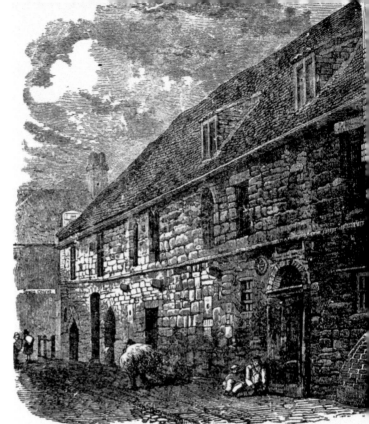

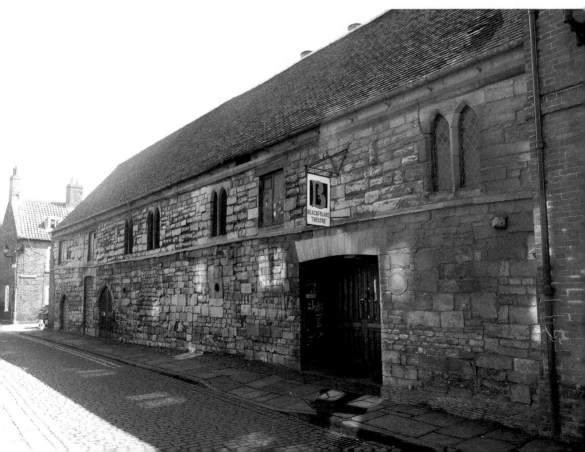

Shodfriars Hall, South Street

Shodfriars Hall takes its name from the friary that stood in the vicinity, the Black Friars or Shod Friars, so called because they wore shoes. Tradition has it, according to a book published by John Noble of Boston under the pseudonym of Roger Quaint in 1841, that it had been owned and lived in by Sebastian Cabot, who, along with his father John Cabot, were renowned explorers and had made significant discoveries across the Atlantic. The building was restored to such extent in 1874 that it was virtually rebuilt and was turned into a theatre. This is where Arthur Lucan (real name Arthur Towle) started out in show business – he went on to make his name playing 'Old Mother Riley', the well-known character he created for stage and screen in the 1930s. In recent years, it has been used as a snooker hall, but now the upper floors are currently empty and awaiting someone to make use of the great potential on offer. The ground floor is in use as two separate shops.

The Loggerheads Pub, South Street
This very old beerhouse was located next to Packhouse Quay on South Street. It is not known exactly when it was first licensed, but certainly by 1784 its full name was The Three Loggerheads, and it once had a swinging sign incorporating three angry-looking Elizabethan men in the design. When the town's football club played at the Shodfriars Lane ground and lacked facilities, the players changed into their kits at The Loggerheads. During the First World War, the pub was the receiving point for donations and food parcels for interned fishermen in German POW camps. The building's location, opposite Shodfriars Hall, made South Street very narrow, which was a significant problem with growing levels of motorised traffic, and it was demolished for road widening in the early 1960s.

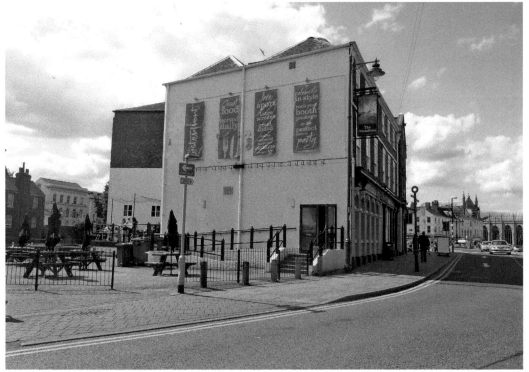

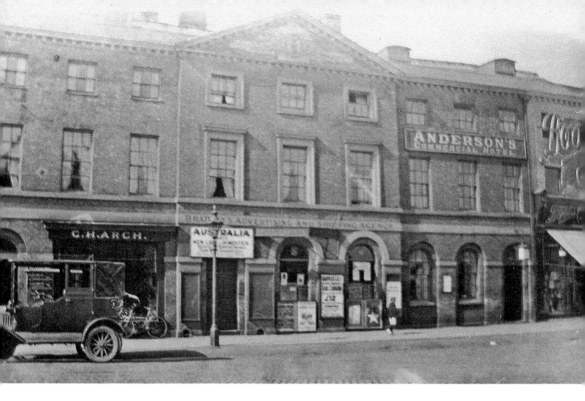

Corporation Buildings

The Corporation buildings in the Market Place were built in 1772, and replaced some very old shops and a stone-built house over the Gully Mouth (where a creek, later converted into a sewer, empties into the Haven). The purpose of the building was to house the council offices, as the town hall situated at the guildhall was not large enough. It has been rented out as offices and shops for more than a century since the opening of the municipal buildings in 1904. Mr Arch (*inset*) had a cycle shop and ran Charabanc excursions.

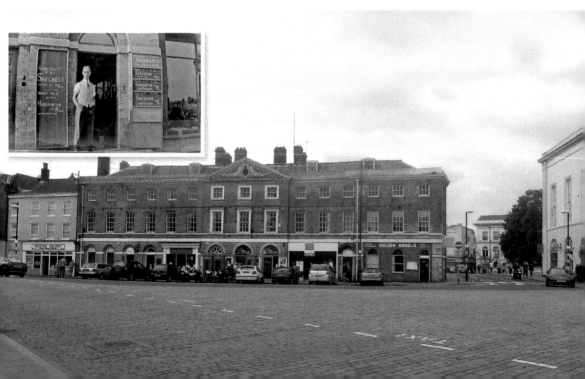

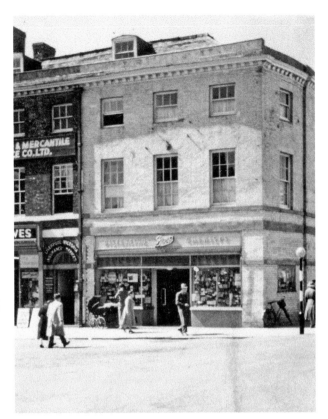

The Former Boots Store
Boots the Chemist occupied this shop next to the Town Bridge, until relocating to a new purpose-built store across the road on the site of the Peacock and Royal inn in the 1960s. Later, it was the premises of the Golden Dragon Chinese restaurant for many years until recently being put up for sale.

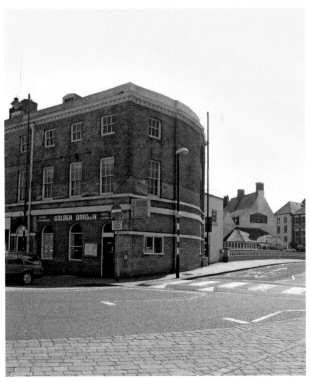

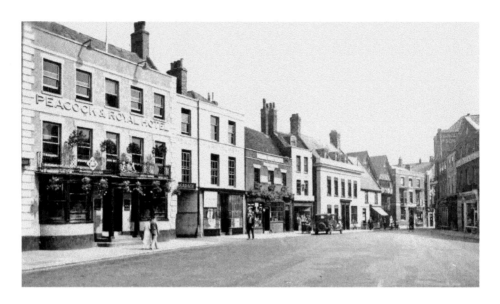

The Peacock and Royal

This was one of the main coaching inns in the town, probably only rivalled by the Red Lion in size, and had the word 'Royal' added to its name after an overnight stay by one of Queen Victoria's sons in 1889. It had been built in the mid-eighteenth century, although an inn of the same name, The Peacock, had existed earlier in Angel Court, so it may have been established even further back in time. Stagecoaches called in here, and there were two coach houses, stabling and a smithy on the site. With the advent of the railways, the inn adapted by operating an omnibus to pick up and drop off passengers at the railway station. After the Second World War, it was run by Batemans and finally closed in 1962, when it was demolished and the new Boots store was built on the site.

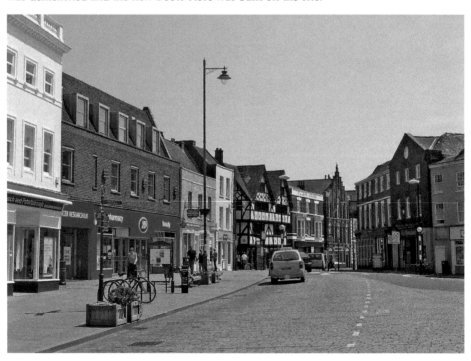

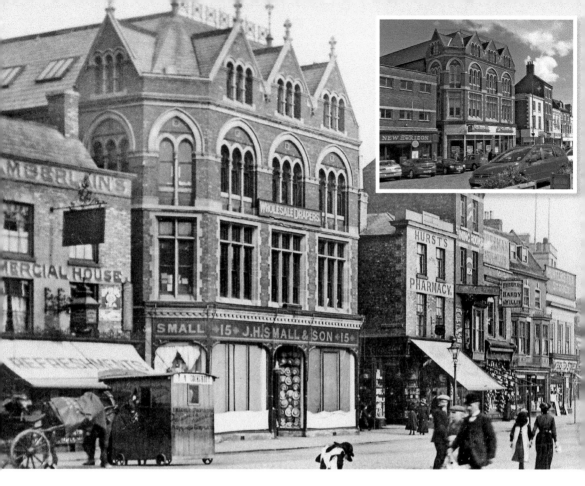

Market Place

The Market Place has been the heart of the town for nine centuries, not only because of the twice weekly market held on Wednesdays and Saturdays, or the annual May Fair, but also because of the various businesses that add character to the life of the town. In days gone by, most of these would have been family-run businesses, with the family and even some of the staff living above the shop. These days, most of the shops in the Market Place are national chains and the rooms above are normally used for storage or left empty. Family-run and independent businesses tend to be located in the many lanes and back streets of Boston's medieval street plan. In the Edwardian view we can see Chamberlain's Hotel, Small's the draper's, then on the corner of Dolphin Lane there's Hurst's pharmacy, then Loveley's the baker's and dining rooms, Freeman Hardy & Willis, Wilson's the grocer, and Hunter's Tea Stores.

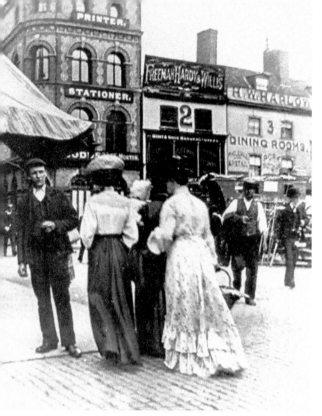

Market Place

The building on the corner of the Market Place and Strait or Narrow Bargate, a printer and stationer's in this late nineteenth-century view, is a recognisable landmark, and is affectionately remembered by the older generation as the Cherry Corner Café, which opened in 1947 as an American-style 'milk bar'. While the shops occupying these premises have changed over the years, it is pleasing to notice that above ground floor these buildings have altered little and retain their old character.

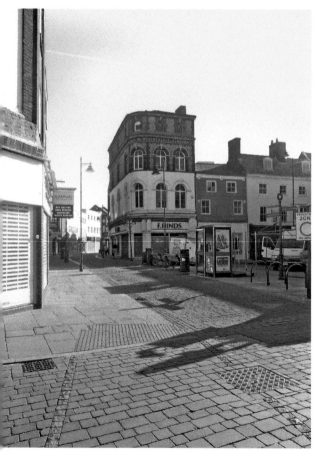

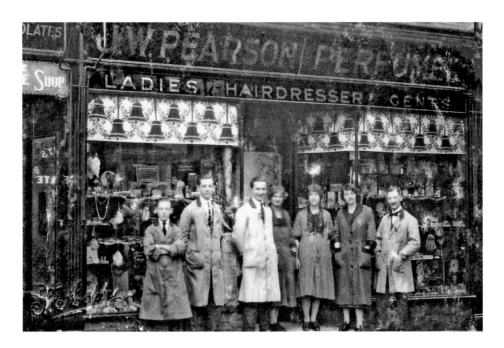

Nos 3–5 Petticoat Lane

The staff at Pearson's hairdressers posed for this photograph at Christmastime sometime in the interwar years. Later, the building was occupied by the town's jobcentre. Now it is home to the local British Heart Foundation charity shop, and the manager and some of her team pose for the modern view of the shop. It is a beautifully preserved, traditional shop building with a distinctive green pantile roof and green painted walls. The windows in the upstairs book department afford magnificent views of the busy Market Place.

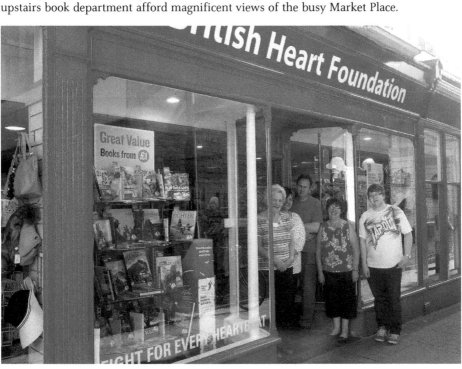

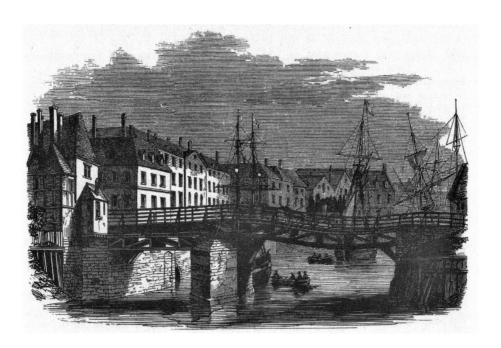

Town Bridge, Looking South

This was the old wooden bridge, which was taken down in 1807 after a new cast-iron bridge, designed by Sir John Rennie, was built. About one third of the way across the river, from the eastern side, there stood a stone pier, which once had sluice gates known as Hake's Sluice, having been erected by Mayhave or Matthew Hake and his labourers from Flanders in 1500. When this was dismantled to make way for the new bridge, many interesting pieces of church masonry were found, such as pillars and arches. These originated from St John's church on Skirbeck Road, which was dismantled in 1626 after falling into disrepair since being abandoned by the Knights Hospitaller. The Rennie Bridge was replaced in 1913 by the current bridge.

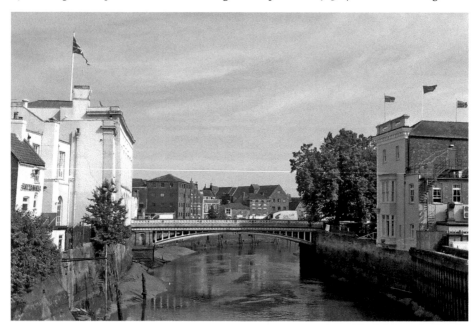

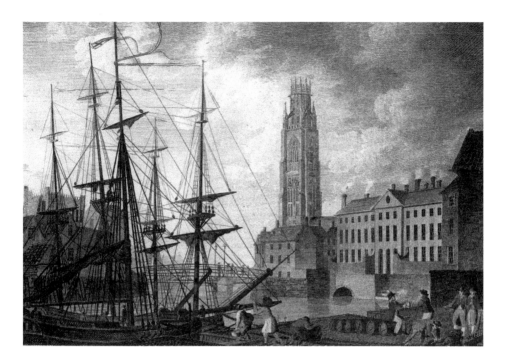

Town Bridge, Looking North

Again, the wooden bridge is seen in this old view from Packhouse Quay, which was where a lot of seagoing vessels were unloaded before the docks were built. The Corporation buildings, on the right-hand side, were built in 1772, and the Gully Mouth can be seen clearly in the old view. The Assembly Rooms are the most obvious addition to the modern view, opened in 1822. Across from the wooden bridge, behind the sailing ship, there's a mysterious tall building that resembles a tower with battlements. This building only appears in this particular engraving of Boston and in no other. As the location is probably at the entrance to Stanbow Lane, this has led to speculation of a possible gateway similar to the Stone Bow in Lincoln. This part of town was inhabited by Lincoln merchants in the medieval era, hence the naming of Lincoln Lane, situated off Stanbow Lane.

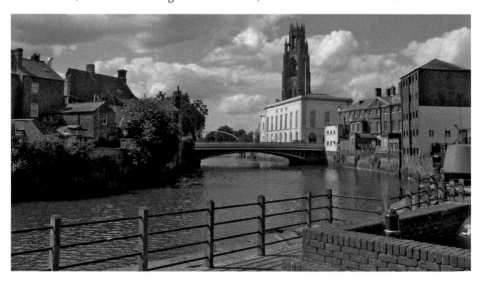

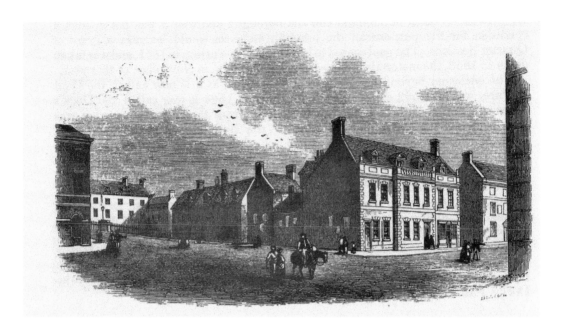

The Assembly Rooms and Fish Hill

The Assembly Rooms is a fine Regency building opened in 1822. Before this time, the Market Place was smaller than it is today and the town bridge was only accessed by means of Bridge Street, which ran behind a row of small cottages and shops, seen in the picture on the left. For many centuries, fresh fish was sold here, straight from the boats that came up to the Town Bridge. The ground floor of the Assembly Rooms accommodated fish shops since it was built until 2010, but there is still a fresh fish market stall here on Wednesdays and Saturdays.

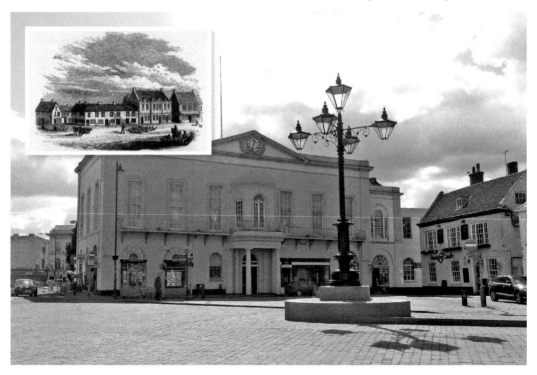

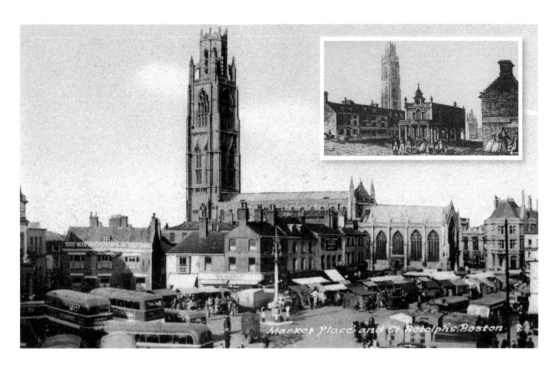

Market Place

There has been a twice weekly market held here, on Wednesdays and Saturdays, for centuries since a Charter given to the town by King John more than 800 years ago. The Five Lamps, in the centre of the old view, was moved for a time but brought back. The Lincolnshire Road Car buses add colour to the 1940s scene above, at a time when many services departed from here, outside the Boots store near the Town Bridge. The seed huts on the right-hand side of the picture were once a familiar sight. Farmers and their clients would make deals in these little huts that were on wheels, which were dragged into the Market Place from a nearby yard where they were stored. The building that once stood in the centre of the Market Place was the Butter Cross, which had an assembly room above, but was pulled down after the new Assembly Rooms were opened in 1822.

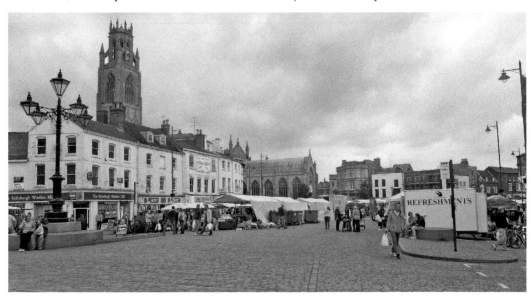

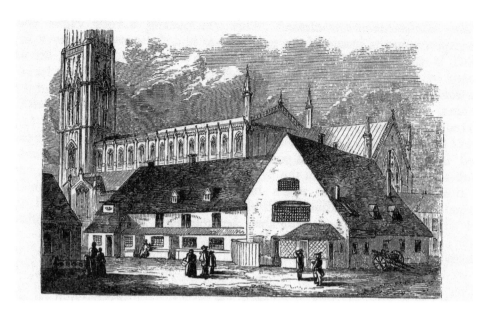

The Churchyard and Herbert Ingram Memorial

The old jail was situated between the Market Place and the church, seen above on the right, adjacent to shops (in the centre), and The Ostrich public house was at the churchyard end of this cluster of buildings. On the far left of the picture, the stocks are visible, in front of the butchery. In 1772, John Parish, who owned the pub and some of the adjacent shops, made an agreement with the Corporation, who owned the remaining shops and the jail, to give up the buildings for demolition to enlarge the churchyard and open up the Market Place. After the untimely death of Herbert Ingram MP in a boat accident in America, his body was brought back for burial in Boston Cemetery and a statue was erected in the centre of town, which features a lady pouring water, signifying Mr Ingram's work in successfully bringing fresh water supplies to the town. There was a large turnout for the unveiling ceremony.

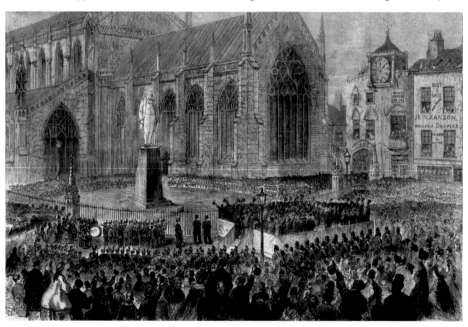

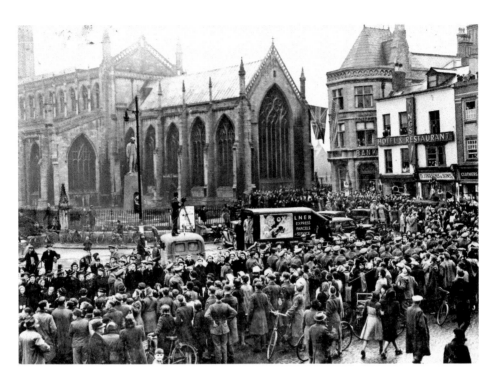

The Churchyard and Herbert Ingram Memorial

This part of the Market Place has been a focal point for townsfolk over the years, and Herbert Ingram's statue has been present as a backdrop to numerous celebrations, declarations, protests, royal visits, annual fairs, religious processions, carnivals and much more, in addition to the twice weekly general market and the Thursday craft market, as seen in the picture below.

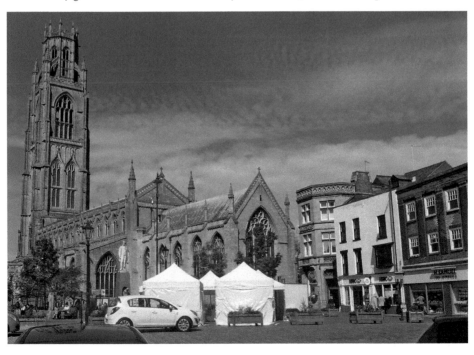

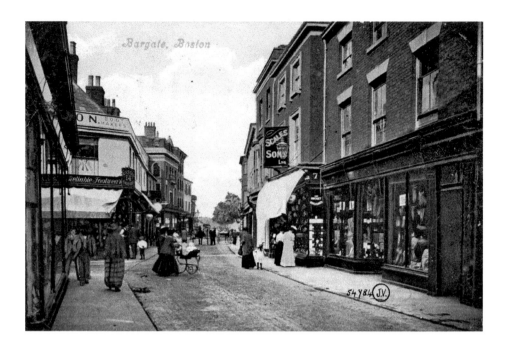

Strait or Narrow Bargate

This narrow section of Bargate, pedestrianised since the opening of the town's relief road – John Adams Way – in 1980, was once the main route through the town. The Bar Ditch, or Bar Dyke, went under this street with a stone tunnel 15 feet in length, which formed the Bar Bridge. The Bar Ditch was a moat or sewer that ran from the Haven north of Wormgate, along the medieval town walls forming an eastern perimeter, with an outfall into the Haven at South End.

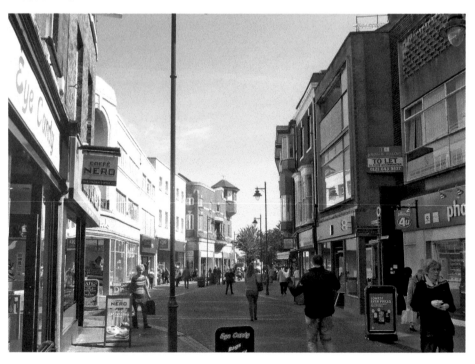

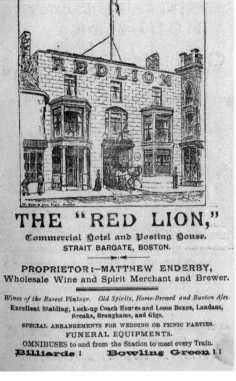

THE "RED LION,"

Commercial Hotel and Posting House,
STRAIT BARGATE, BOSTON.

PROPRIETOR:—MATTHEW ENDERBY,
Wholesale Wine and Spirit Merchant and Brewer.

Wines of the Rarest Vintage. Old Spirits, Home-Brewed and Burton Ales.

Excellent Stabling, Lock-up Coach Houres and Loose Boxes, Landaus, Breaks, Broughams, and Gigs.

SPECIAL ARRANGEMENTS FOR WEDDING OR PICNIC PARTIES.
FUNERAL EQUIPMENTS.

OMNIBUSES to and from the Station to meet every Train.

Billiards ! Bowling Green ! !

The Red Lion, Strait Bargate

This was one of the most important coaching inns in the town, situated in the narrowest part of Bargate and lending its name to Red Lion Street to the rear. As a tavern, it belonged to St Mary's Guild until all religious guilds were dissolved and their property seized during the Reformation in the reign of King Henry VIII. The inn was demolished in 1962 to make way for a new Woolworths store.

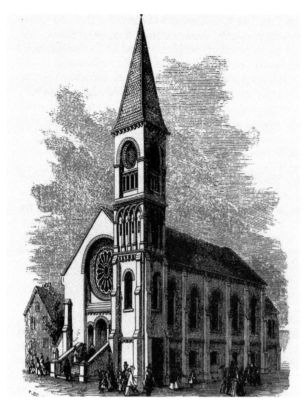

The Congregational Church

A theatre had existed on this site, opened in 1806, until it was purchased in 1849 and demolished to make way for the building of the Congregational church (*above*), which had a tower and spire, and also a schoolroom for 400 boys and girls on the ground floor beneath the chapel. It was opened in November 1850 but, incredibly, it only survived until 1867, when it was pulled down and replaced with a new church building (*below*) with a larger capacity for worshippers. It was built by Sherwin's of Boston with the memorial stone laid, and organ paid for, by Mr John Oldrid. The church has now gone, leaving an empty space currently used as a car park.

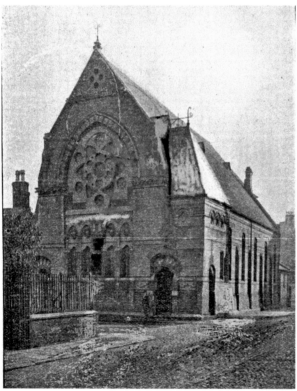

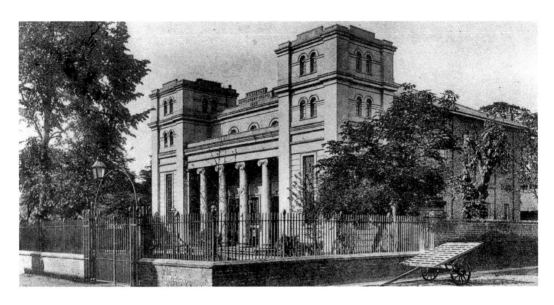

Methodist Centenary Chapel

The Methodists have had a strong base in Boston since the days their founder, Lincolnshire cleric John Wesley, visited the town and preached here, and their first chapel was on Wormgate. The above chapel was built in what was then called Red Lion Square in 1839, after they purchased the site and raised £2,800 in a single day toward the cost. It was in this chapel that the young Catherine Mumford attended and developed her faith before moving to London and co-founding the Salvation Army with her husband William Booth. The building was opened on 1 October 1840, but sadly it was completely destroyed by fire in 1912, after which the present building, shown below, was built to replace it.

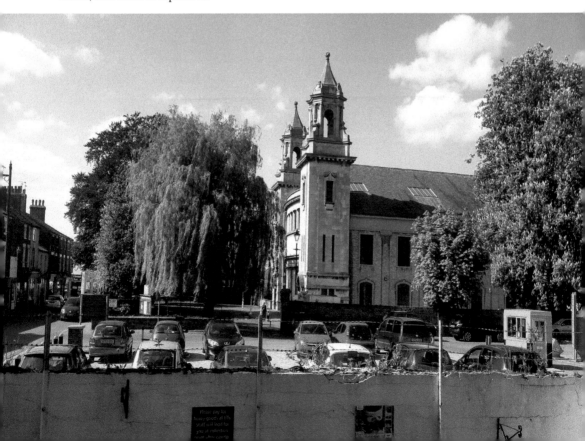

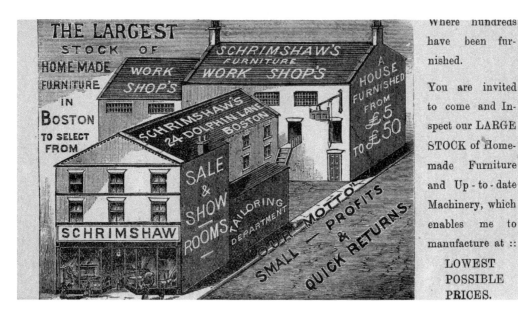

Dolphin Lane

Schrimshaw's Furniture Shop and Workshops were located at No. 24 Dolphin Lane, next to the Dolphin Inn from which this old medieval lane took its name (the original name of the lane is unknown). The inn dated back centuries and had its own brewery in nearby Silver Court, but it was closed down in the late 1890s, probably due to its poor reputation with regard to behaviour. Ironically, a local draper called Mr Small, who had the draper's shop in the Market Place, took the building over as a meeting room for the local Temperance society (who worked to encourage teetotalism). Schrimshaw's made furniture that was affordable for the working class, and they even built their own household appliances such as this revolutionary washing device promising to take the 'drudgery out of wash day', so it is pleasing that there is some continuity with the Regency Dry Cleaner's standing on this site today that can also do just that.

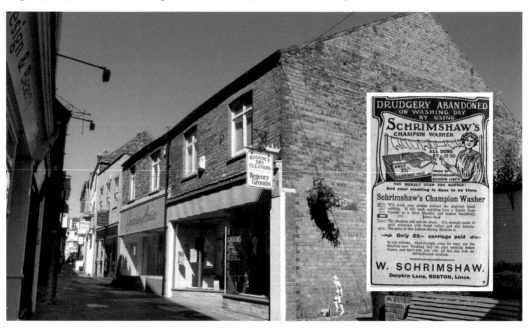

Pescod Hall and Gatehouse

The Pescod family were wealthy merchants in the fourteenth and fifteenth centuries. A brass memorial plaque commemorating Walter Pescod, who died in 1398, still exists in St Botolph's church. The building, known today as Pescod Hall (*inset*), was built in the mid-fifteenth century, but at the time was only the living quarters attached to a 'Great Hall', which extended to a length of about 40 feet, but was later demolished in the late sixteenth century. A gatehouse straggled Mitre Lane, previously called Pescod Lane. The gardens extended to Thieves Lane, later called Silver Street, from where one would stand to take in this view. Today, the modern Pescod Square makes for a pleasant shopping experience, but its construction involved moving Pescod Hall, which had stood across the street opposite Boston's Oldrids Department Store, who owned and had restored the building in 1972 by methodically taking it down piece by piece and completely rebuilding it.

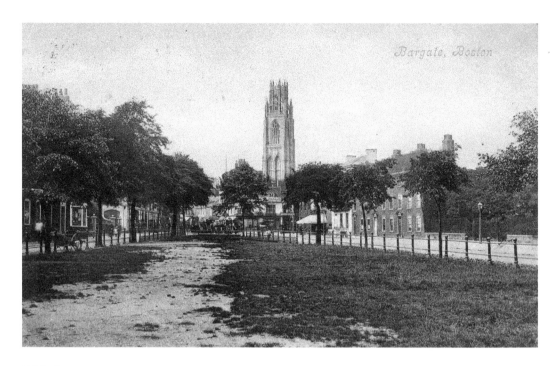

Wide Bargate

A row of Georgian town houses on the right hand side were taken down to make room for a purpose-built General Post Office opened with much excitement on 12 December 1907 by the Postmaster General. Despite vocal concerns expressed by members of the general public, sadly this Crown post office quietly closed its doors for the last time on 12 February 2014 without ceremony. The hope is that this fine building will not be vacant for very long.

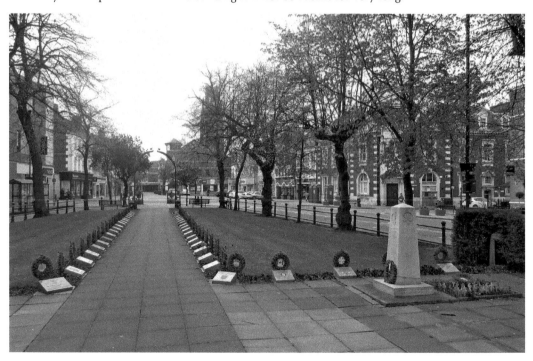

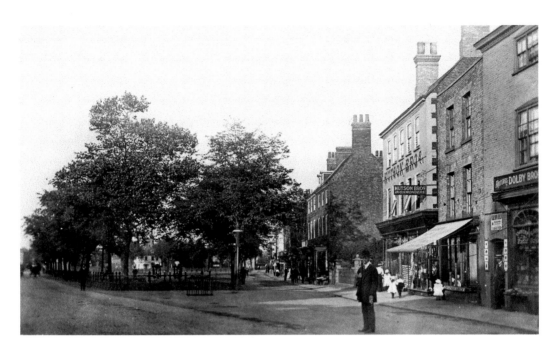

Wide Bargate

On Bargate Green a war memorial was unveiled in 1921 by the Earl of Yarborough, Lord Lieutenant of Lincolnshire, dedicated to Bostonians whose lives were taken in war since 1914. In the earlier view, there are two cannons in the centre of the picture, which were presented to the town by the War Office following the Crimean War. After the 1914–18 war, a British tank and a German field gun were also located here, but removed in the 1930s. On the right-hand side there is an opening to Silver Street, which today is the entrance to the Pescod Square shopping centre.

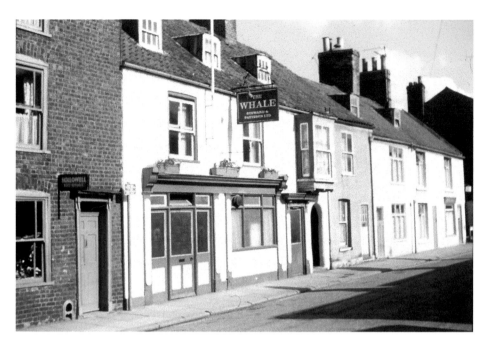

Main Ridge

For centuries, Main Ridge has been an important route for people heading into Boston from the villages to the east. The photograph above was taken in August 1974, before the John Adams Way relief road was built, and to make way for it, a significant part of the town was affected. A great deal of the town's heritage was bulldozed, businesses and homes were compulsory purchased and flattened, and the heart of the community – the much-loved Whale Public House – was lost forever. The new road relieved the Market Place and Bargate (which had until then been the route of the A52 and A16) of cars, heavy goods vehicles and buses. Eagle's fish and chip shop, occupying the far end house to the right in the old view has been extended into the neighbouring two properties. There has been a chippy there as long as anyone can remember, and before Mr Eagle took it over, it had been Ainsworth's, and before that Upsall's. The alleyway below the bay window of The Whale led to the rear or Caroline Street, now renamed Field Street. The shoe repair shop belonged to Mr Hollowell, who used to hang second-hand shoes and boots for sale on a pole outside by the door.

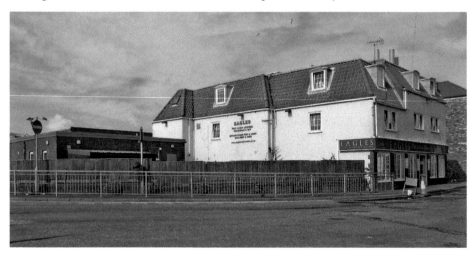

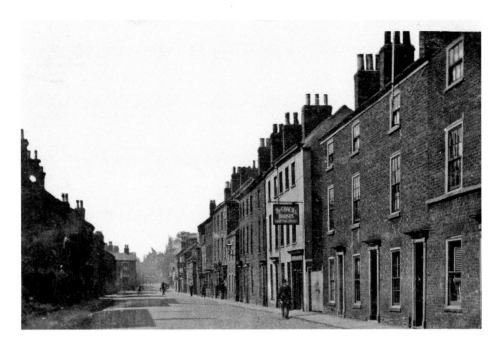

Main Ridge

The 'Main Rigg', as its name appears on early maps of the town, was merely a footpath or track surrounded on both sides by the town fields, until the Georgian era expansion of the town in the boom years following fen drainage. It soon blossomed into a self-contained community, as the older generation can today recall the many shops and businesses that used to be along here, most of which are long gone. The building of the John Adams Way relief road in the 1970s truncated this thoroughfare into Main Ridge East and Main Ridge West, and the level of traffic today would make it very difficult to rekindle this former community spirit.

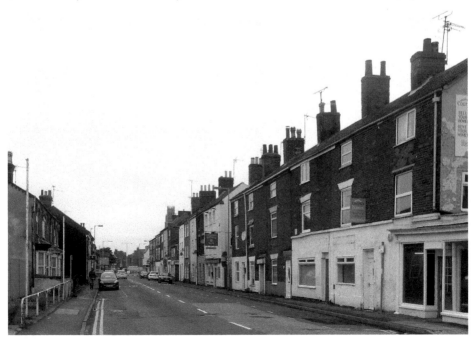

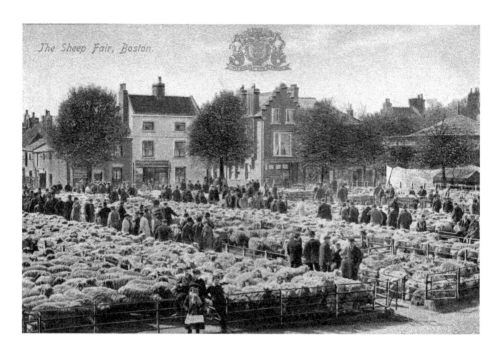

The Sheep Fair, Boston.

Sheep Fair, Wide Bargate Looking Toward Pen Street

In this Edwardian era scene, the sale of sheep is still important, but the traditional mechanised merry-go-rounds had begun to make an appearance. By the mid-twentieth century, while there were still displays and sales of agricultural machinery, the amusement side of the fair had taken over. The annual May Fair continues to attract thousands of locals and visitors to the town, keen to enjoy the fun and thrills to be had on the hundreds of rides that are packed into the town centre, stretching from John Adams Way all the way to the far end of the Market Place. Boston has always been a big event for the fairground families, one such family was the Aspland-Howdens, who pioneered many of the early steam-powered mechanised rides and who had their main workshops in Main Ridge, Boston.

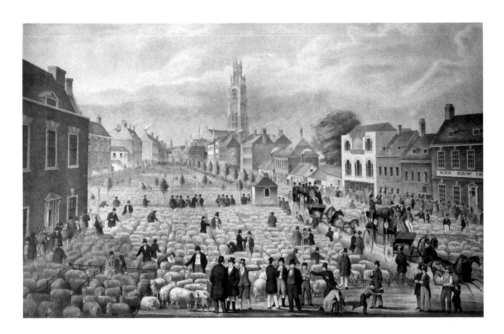

Sheep Fair, Wide Bargate Seen From Bargate End

The annual May sheep fair was huge in the nineteenth century, with thousands of sheep penned in on Bargate Green. With huge numbers of farmers and dealers visiting the town for fair week, it always attracted large numbers of entertainers providing amusement and sideshows, eager to relieve them of their boredom and spare cash during the evenings. There would be magicians, fortune tellers, circus acts, boxing, pantomime and other theatrical shows, dancing, musicians and stalls. Two stagecoaches are leaving town, having just passed the toll booth on the Wide Bargate-Pen Street corner. The old metal plate turnpike sign is still to be found in the pavement on Wide Bargate outside the Cammack's store. These stagecoaches were the Louth Mail and the Hull Mail, which were despatched within five minutes of each other before nine in the morning. Modern coach travellers are able to travel up from London in air-conditioned comfort in a little over four hours.

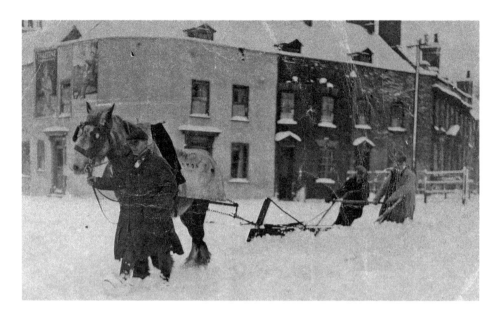

The North Pole

The white building on the corner of Mill Hill was known as The North Pole, and in the picture above it certainly looks like they were having polar weather conditions. That was back in the winter of 1946/47. The reason for the name was that this was a beerhouse between 1874 and 1908, called the North Pole. The street named Mill Hill was actually a kind of irregular rectangle of Georgian town houses that faced outwards, with the square behind them carved up into yards like segments of an orange. Mr Ayre, who lived at the 'North Pole', took in bicycles for safekeeping in his yard, starting with soldiers from a nearby camp during the First World War, but later on for civilian folk too, while they went about their business in the town. In the late 1960s, the whole of Mill Hill and the old cattle market next to it were cleared away, the only reminder being the name of the car park on the site, Cattle Market car park.

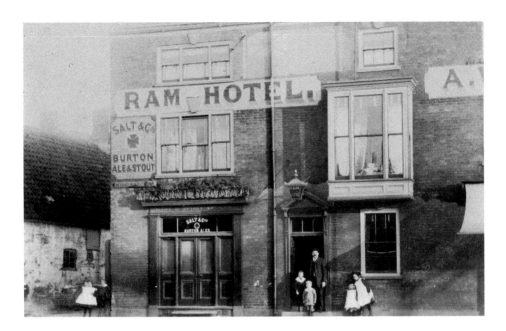

The Ram, Wide Bargate

This was the Ram Hotel, and next door on the right was A. Wright butcher's shop. This inn existed as long ago as 1564, but the present building probably dates from the mid-eighteenth century. Beer was brewed on site and there was a tap house at the back, as well as a large yard with stables, coach houses and even a slaughter house. In the old days, carrier carts came in from the villages on market days, bringing people for business or shopping, and they would always use a designated pub or inn in the town for arrivals and departures, and for their horses to be fed and watered. The Ram served as a base for many of these, including carriers from Carrington, Sibsey Northlands, Leverton and Wainfleet. The inn closed in 1990, and today the building has been turned into flats – the ancient looking cottage on the left has long since disappeared, with the John Adams Way relief road running through here over the top of what used to be Cheyney Street.

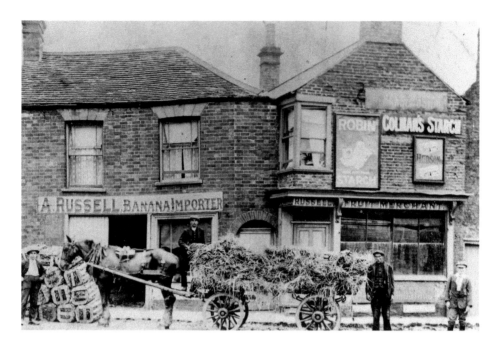

Wide Bargate

This was the premises of Alfred Russell, who was a fruit importer, and this photograph, with him standing on the left, was taken in around 1919 or 1920. Mr Russell was known locally as the 'Banana King', and his house on Pen Street was called Jamaica House, as he was the first to import bananas from Jamaica to Boston. His business premises, seen here, was located on Wide Bargate, but today there are no clues left of its existence, and the New England Hotel occupies the site. This hotel was formerly known as 'The Cross Keys', which is the symbol for St Peter and St Paul – a reference to the St Peter and St Paul Guildhall that was originally located on this site.

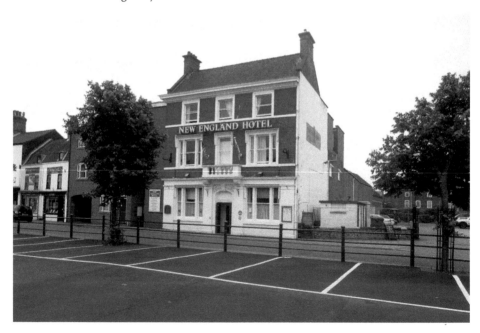

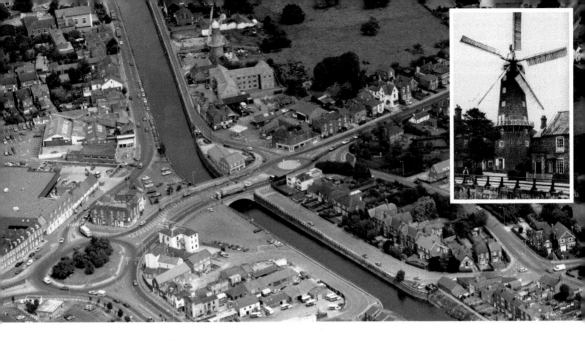

Maud Foster Mill, Willoughby Road

The mill, overlooking Maud Foster Drain, was built in 1819 for Thomas and Isaac Reckitt, who were millers, corn factors and bakers. A steam engine built by Tuxford's Iron Foundry in Skirbeck was installed. The Reckitts went out of business in 1833, but later Isaac Reckitt founded the famous Reckitt's starch business (Reckitts Blue) in Hull. The mill was later run by the Ostler family from 1914 to 1948, but it probably owes its survival to essential repairs made in the 1950s funded by the Reckitt Family Charitable Trust. Today, this is still a working windmill, restored and owned by the Waterfield family, and is open to the public twice per week, in addition to having holiday accommodation in the attached old granary building to the side of the round mill tower. The original contract for building it is on display in the mill shop.

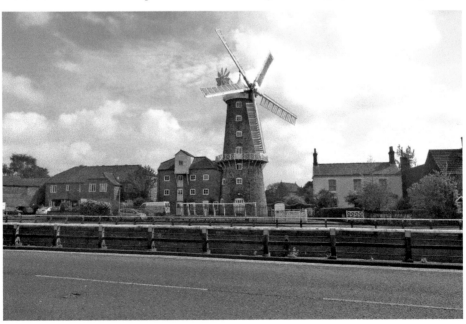

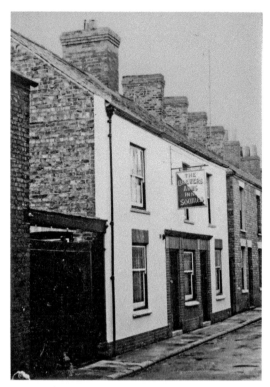

The Brewers Arms, Norfolk Place
This little beerhouse was first licensed
in 1875. It was situated at No. 24 Norfolk
Place, a narrow residential street to the
north of the town centre. It was closed in
around 1960, and the building was pulled
down. The modern houses on the left were
later built on the site.

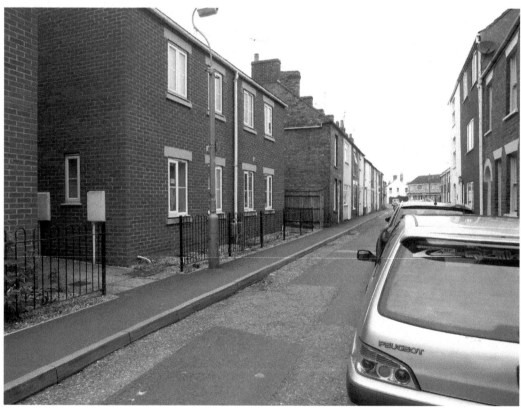

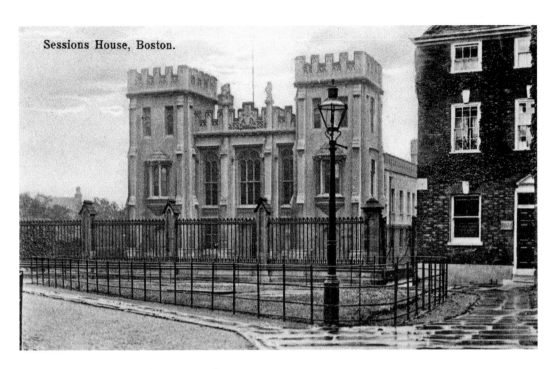

Sessions House, Boston.

Sessions House and County Hall

The Sessions House, here on the left, was the magistrates' court, built and opened in 1842, but closed and disused since the court was moved to alternative premises on Norfolk Street in 2010. On the left, the County Hall replaces an earlier building on the site, and while now it still houses the town's library, until recently it also housed the local registry office. As the name implies, it was formerly the offices for Holland County Council – a tier of local government that was swept away with the local government reorganisation of 1974.

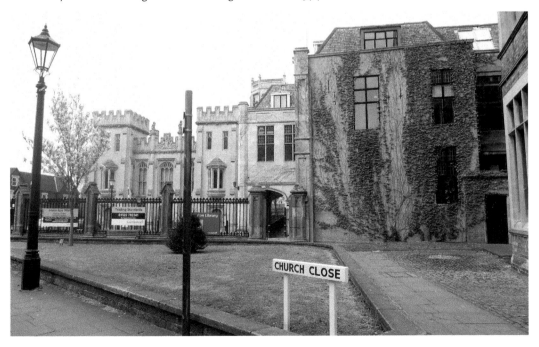

CHURCH CLOSE

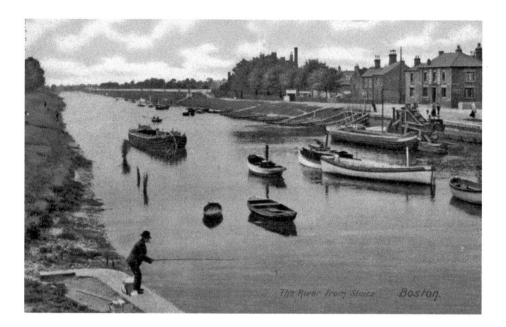

The River from Sluice. Boston.

Witham Bank, Looking North

The Witham was crucial to the thriving economy of medieval Boston, providing the only sensible option for the transportation of goods between the ancient City of Lincoln and the seagoing vessels at the Port of Boston, and the exports of wool from the many sheep -owning monasteries located in the Fens north of here, which contributed to the wealth of medieval Boston. Even in the nineteenth century, the poor state of the roads and the obvious limitations on horse-drawn transport meant the navigation of the Witham was relied upon for both passengers and cargo. After the opening of the railways, there was fierce competition between the steam-powered boats or barge operators and the railway company, and while river transport was cheaper, it was much slower. Today, the railway line to Lincoln has gone, and the only river traffic is for leisure purposes.

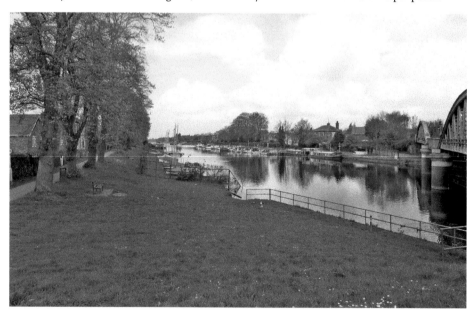

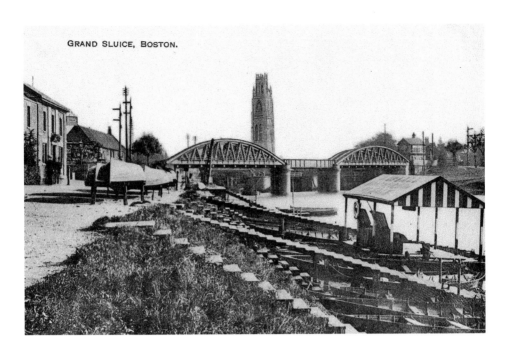

GRAND SLUICE, BOSTON.

Boston Marina

There was a time when a little rowing boat could be hired here on Witham Bank East, just north of the Sluice Bridge. Times change, and now there are numerous privately owned, modern boats moored up at Boston's Marina, making the River Witham look very attractive indeed. On the eastern bank, on the left of the picture below, refreshment can be taken in either the Witham Tavern or a café next to the sluice gates and the departure point of the *Boston Belle* passenger boat. Witham Bank East, pictured here, makes a particularly pleasant walk as it leads to the Witham Woods.

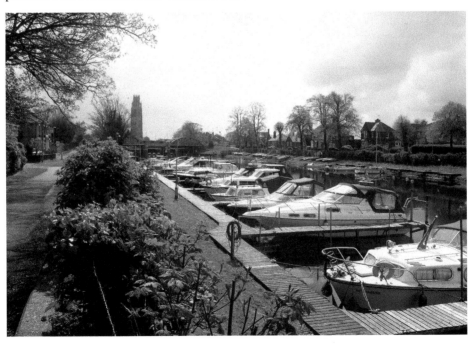

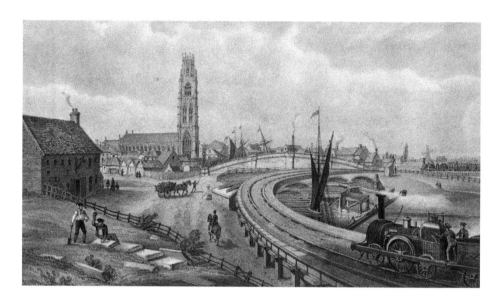

The Grand Sluice Railway Bridge

The Grand Sluice, completed in 1766, is a triumph of eighteenth-century engineering, separating the tidal seawater of the Haven from the River Witham, incorporating massive floodgates, which are used to maintain a consistent and navigable depth for the Witham upstream to Lincoln. The railway line was sited so as not to inconvenience the mooring of river barges, but its alignment north of the sluice was highly controversial at the time. The East Lincolnshire Railway, together with the Great Northern Railway, with the support of Boston Corporation, proposed to cross the river south of the sluice, which meant the station could be located closer to the town centre. However, the decision-making powers on matters affecting navigable waterways lay with the Admiralty, who ruled against it. The illustration above (published by John Noble of Boston, a keen supporter of the failed campaign to take the line south of the Grand Sluice) shows how the original line curved very sharply over the river.

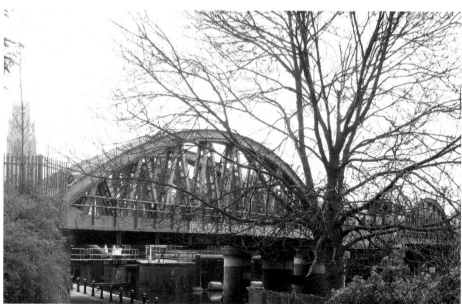

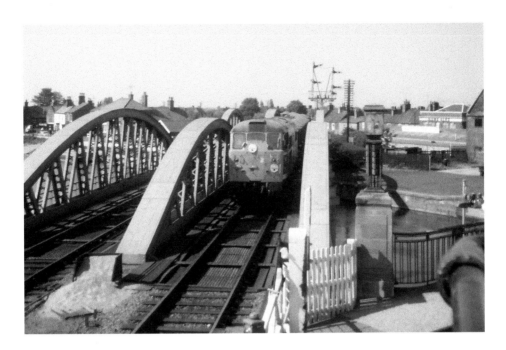

The Grand Sluice Railway Bridge

The Grade II listed GNR cast-iron three-span Railway Bridge opened in May 1885, replacing the earlier iron and timber bridge. An express freight train carrying ballast from Grimsby on the Up line is seen from the Sluice Bridge signal box on 5 June 1970, just four months before the East Lincolnshire main line between Firsby and Grimsby was closed due to Beeching's cuts. In 1981, the Up line tracks were lifted as British Rail commenced single line working between Boston station and Sibsey. Now Up trains use the Down line, as seen in the modern view of a Skegness to Derby Express, partly obscured by the arches of the southern side of the bridge, which has had its track lifted.

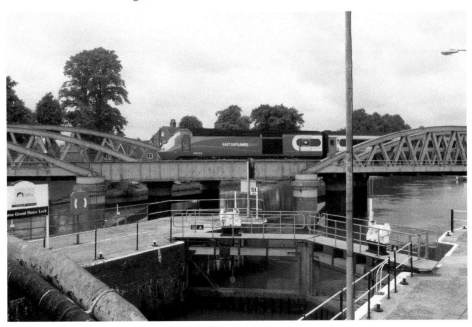

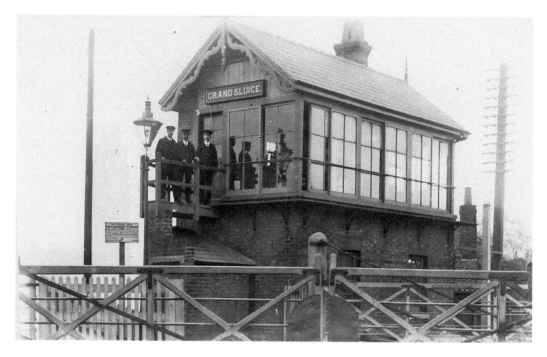

Grand Sluice Level Crossing

The Grand Sluice signal box, along with the other GNR signal boxes at Sleaford Junction (near the bottom of King Street), Sleaford Road (near the Boardsides), and the Maud Foster box on Horncastle Road, became redundant by British Rail's modernisation work in the 1980s, which put all signalling in the Boston area under the control of the West Street Box, hence their demolition soon after.

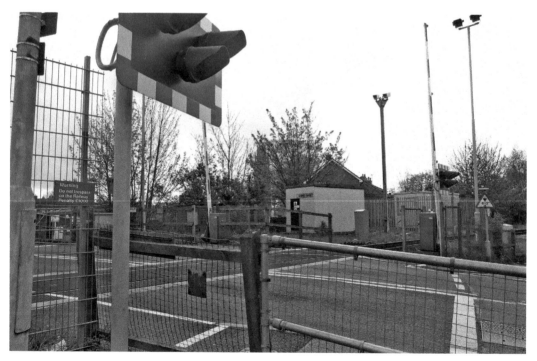

Fydell Street

The corner shop was once an institution, but sadly some of them have disappeared, such as this one of the corner of Fydell Street and Castle Street, close to the Sluice Bridge. All that remains is the postbox in the wall.

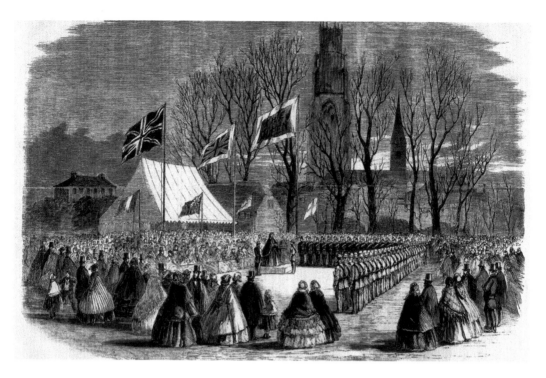

Central Park

Oldrid's Park was bought by the Boston Town Council in 1919, and was laid out to form a park accessible to the general public and renamed Central Park. It had been larger, but some land was built upon to create new streets such as Tunnard Street and Thorold Street. The street names commemorate the original families who owned this land, which formed the gardens of their grand house on Wide Bargate, last lived in by the Oldrid family, and later occupied by the Trustees Savings bank and now split between a restaurant and offices. In 1860, the above illustration of a special presentation event involving the Boston Artillery Corps appeared in the *Illustrated London News*, founded by Boston-born Herbert Ingram. The park once had a goldfish pond and a miniature golf course, which are sadly not there now, but there are still aviaries, a well-equipped children's playground, tennis courts, a bowling green and, more recently, various outdoor exercise equipment (an example seen here) are located at several points around the park and a community vegetable plot has been added.

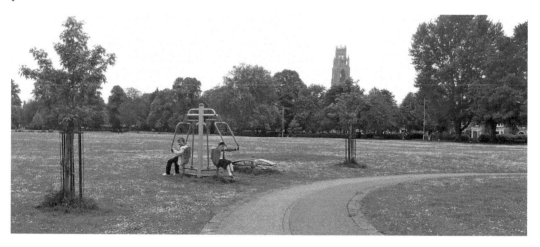

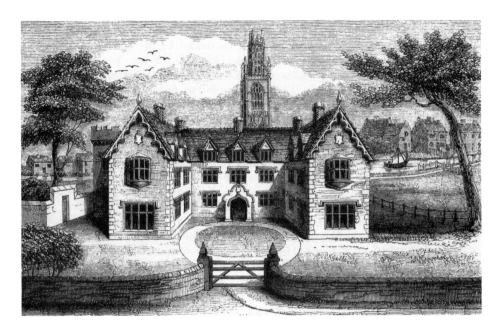

Irby Street

Irby Hall was a fine-looking mansion that had been home to the Irby family from around the reign of Elizabeth I to the early 1700s. The Irbys were influential landowners in South Lincolnshire and were also lawyers, several of them represented Boston as members of Parliament in the sixteenth, seventeenth and eighteenth centuries. Sir William Irby held high office with the Royal family and was made a peer in 1761, with the hereditary title of Baron Boston. Sir Anthony Irby (1605–1681), while he was Sheriff of Lincolnshire, refused or avoided paying King Charles I's ship money tax. At the outbreak of the Civil War in 1642, he raised a cavalry troop for the Parliamentarians and, holding the rank of captain, he arrested a leading local Royalist, Sir Edward Heron, and sent him to the Tower of London. It is thought there are vast remains of the cellars or foundations of this great mansion underneath the garages and houses in this modrn view.

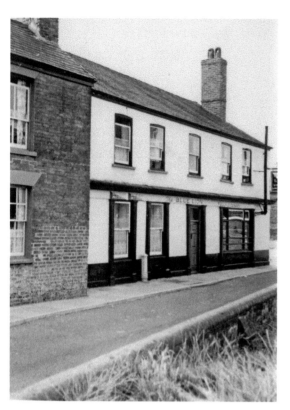

The Blue Lion

The Blue Lion was located at No. 28 Stanbow Lane on the corner of Lincoln Lane, overlooking the river with views of the Stump. It was first licensed as a beerhouse in 1865, but was closed down in 1964 and was demolished soon after to allow for redevelopment of the whole area. By that time, many houses had already been compulsory purchased, the residents moved on to new council estates on the edge of town, and their old homes demolished.

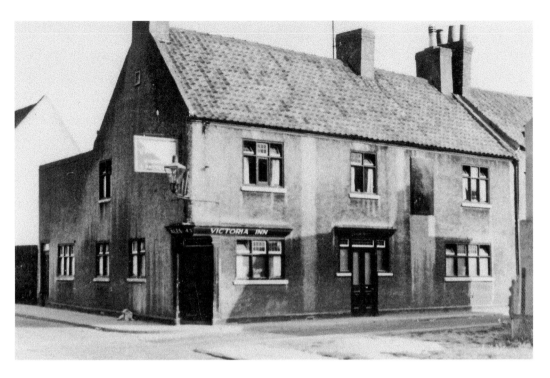

The Victoria Public House, Rosegarth Street

The Victoria was a small beerhouse located at No. 43 Rosegarth Street on the corner of Lincoln Lane, which had opened in 1875 but closed in 1960, when several streets in the area were flattened in 'slum clearances' so that the area could be redeveloped and modernised.

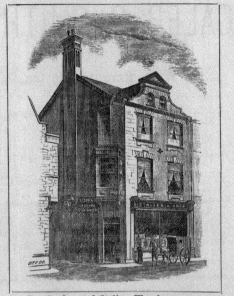

JOHN ALLEN,
FAMILY GROCER,

Tea Dealer and Italian Warehouseman,
8, HIGH-STREET, BOSTON.
SHIPPING SUPPLIED.

High Street

The High Street is probably the oldest street on the west bank of the river, and was the main route bringing travellers from London for centuries. Until the opening of John Adams Way in around 1980, this was the main A16 trunk road. Since then, the street has declined in importance and has become quite neglected. In its heyday, the street was home to dealers of quality merchandise, such as John Allen the grocer, whose advertisement is reproduced here.

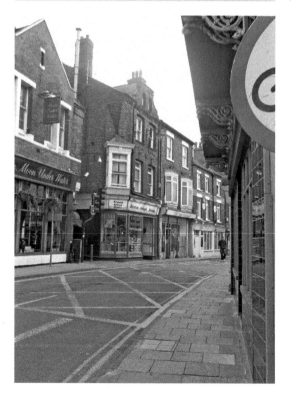

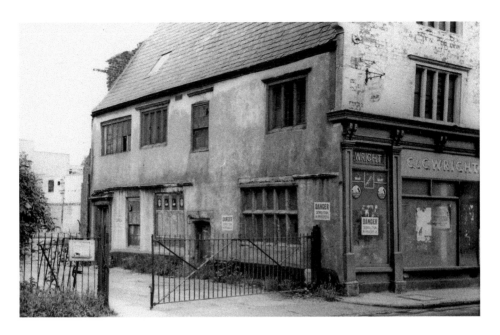

High Street

The Carmelite Friary is believed to have been located in this vicinity, but was probably demolished not long after the Reformation in the sixteenth century. It could be that some of the remnants of window frames and stonework were reused in this building, seen here just before demolition in the 1970s. Before demolition, it was last occupied by C. & C. Wright, builder's merchants, and appears to have had a shopfront added some time in the nineteenth century. Today, the site is used as a car park, but the demolition of the building reveals the timber-framed gable end of the neighbouring shop to the right, with its long hall to the rear, all pointing to its fifteenth-century origins. It has had a nineteenth-century façade added, and was once the Rodney and Hood Public House, until it closed in around 1914. To the left of C. & C. Wright's was once the Quay Picture House, otherwise known as 'the Cosy', which burnt down in 1930.

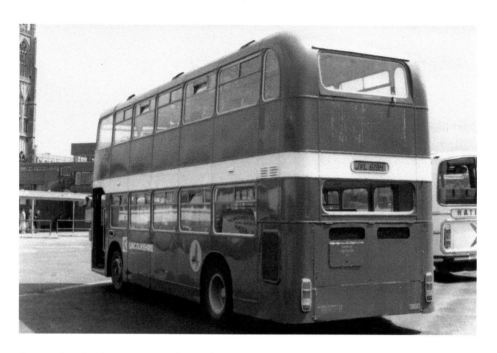

Boston Bus Station, St George's Road

This was the location of the bus station, built after the 'slum clearance' of the early 1960s, replacing streets and little courtyards, which had once housed working class families in often overcrowded and poor living conditions. The bus station has since been moved across the road, and this site is now used as a coach park. It is not unusual for the number of visiting coaches to be in double figures on a market day. The Lincolnshire Road Car double-decker bus, pictured here, was in service between 1969 and 1989, before spending ten years as a 'Playbus' in Milton Keynes. It has now been carefully restored by Richard Belton, which took nine years. Today, the vehicle is back on the road and takes passengers during special open day events at the Lincolnshire Vintage Vehicle Society museum in Lincoln, and is often present at vintage vehicle rallies in the local area.

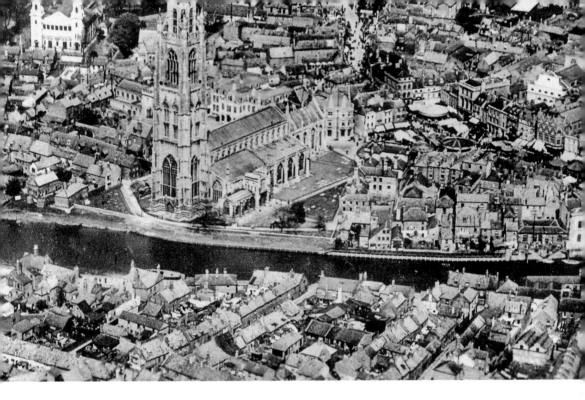

St George's Guildhall, St George's Lane

The inset illustration appeared in the *Boston Guardian* newspaper in 1893, after the building had been purchased by local builder Mr Dickinson, standing in the doorway, who proceeded to demolish this fifteenth-century former guildhall. After King Henry VIII had seized all property belonging to religious guilds and monastic orders, St George's Guildhall became the property of a wealthy family and was known as Lodswick Hall. By the nineteenth century, it had been split into tenement housing and was so neglected by the landlord that there was no prospect of saving it. Its approximate location would have been in the centre of the modern view below, which shows the Social Security Office on the left and the police station on the right.

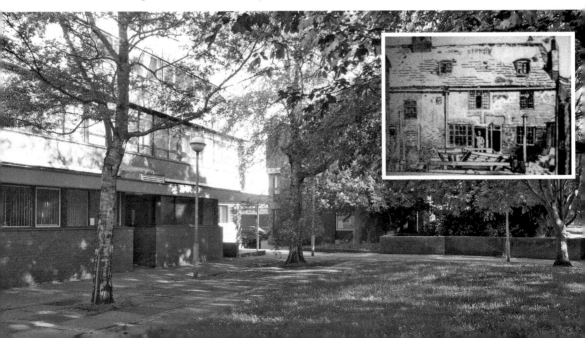

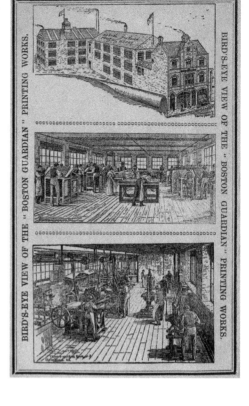

"Boston Guardian" Works,

94, West Street, Boston.

BIRD'S-EYE VIEW OF THE "BOSTON GUARDIAN" PRINTING WORKS.

BIRD'S-EYE VIEW OF THE "BOSTON GUARDIAN" PRINTING WORKS.

West Street

The *Boston Guardian* newspaper had its office and printing works at No. 94. During the Victorian era, there had been a number of rival newspapers, but the *Boston Guardian*, a liberal left-leaning newspaper, which had the backing of Liberal MP Herbert Ingram, was the leading newspaper in the town for the better part of a century. Along with other Victorian era shops that sadly began to deteriorate, it was pulled down in the 1990s and a modern pizza restaurant has been built in its place. West Street is now at the centre of the town's nightlife scene, with various restaurants and a nearby cinema, pubs and clubs.

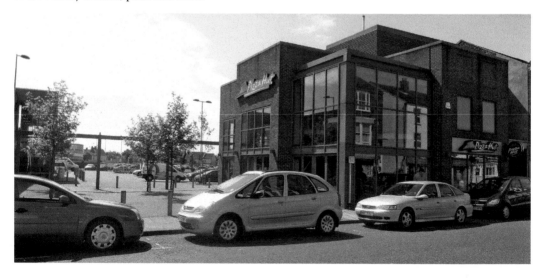

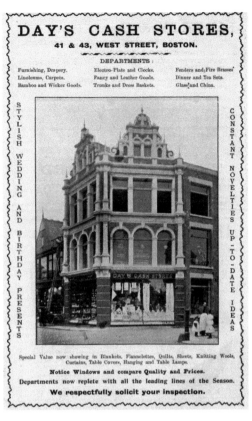

DAY'S CASH STORES,
41 & 43, WEST STREET, BOSTON.

DEPARTMENTS :

Furnishing, Drapery.	Electro-Plate and Clocks.	Fenders and Fire Brasses.
Linoleums, Carpets.	Fancy and Leather Goods.	Dinner and Tea Sets.
Bamboo and Wicker Goods.	Trunks and Dress Baskets.	Glass and China.

STYLISH WEDDING AND BIRTHDAY PRESENTS

CONSTANT NOVELTIES UP-TO-DATE IDEAS

Special Value now showing in Blankets, Flannelettes, Quilts, Sheets, Knitting Wools, Curtains, Table Covers, Hanging and Table Lamps.

Notice Windows and compare Quality and Prices.

Departments now replete with all the leading lines of the Season.

We respectfully solicit your inspection.

West Street/Rosegarth Street Corner

Day's Cash Stores was a very prominent department store in the first half of the twentieth century, at a time when West Street was an important part of the town's shopping experience. Local people over a certain age have fond memories of this particular shop and it had a very good toy department. Sadly, this beautiful building, situated as it was on a street that became the main exit road from the bus and coach stations after redevelopment of the area, has gone to allow for road widening.

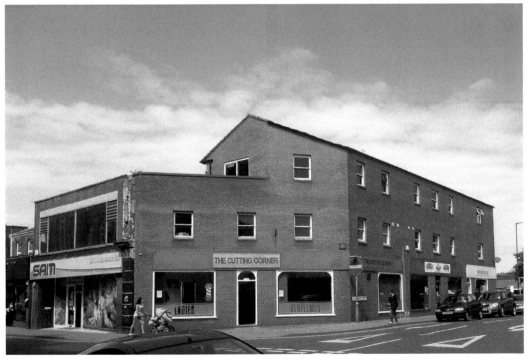

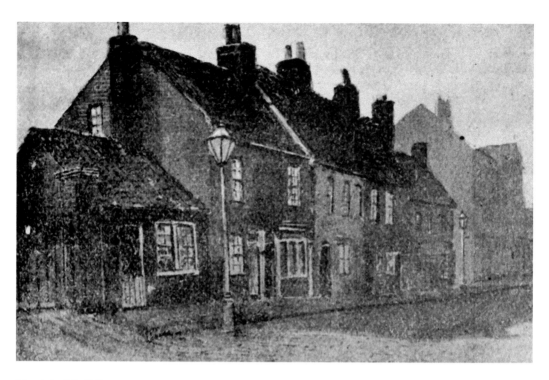

Municipal Buildings, West Street

Several very old shops and houses were cleared to make way for an impressive new headquarters for the Corporation of Boston. The municipal buildings were opened in 1904 and housed council offices, which it still does today, in addition to the police station, fire station and library.

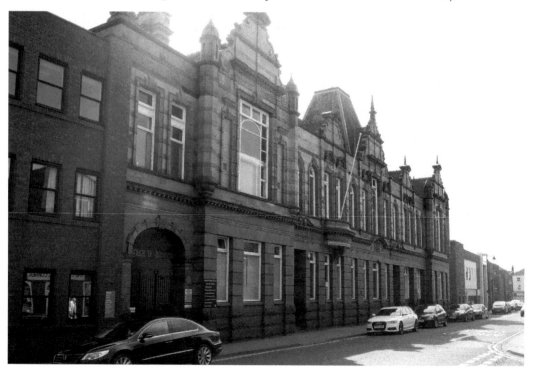

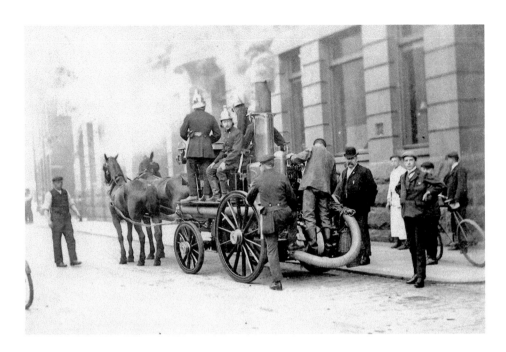

Fire Brigade

Following the opening of the municipal buildings on West Street, the fire brigade was based there, and while the Corporation of Boston supported the brigade, a fixed charge was made for attending a fire, the money going towards their upkeep, as all the members of the brigade were volunteers and most were St John's Ambulance men also. If there was a fire, it was to be reported to the police station, also housed at the municipal buildings, and the brigade were alerted by the ringing of an electric bell fixed to the Assembly Rooms. The fire service later had a small fire station on Lincoln Lane before a modern purpose-built fire station was built on Robin Hood's Walk in the 1960s, pictured below.

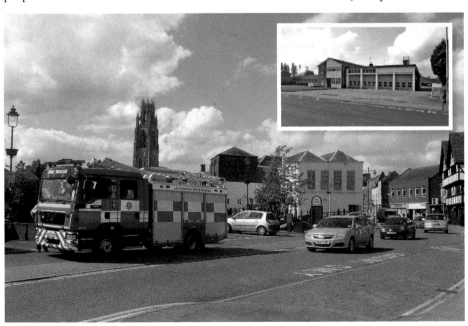

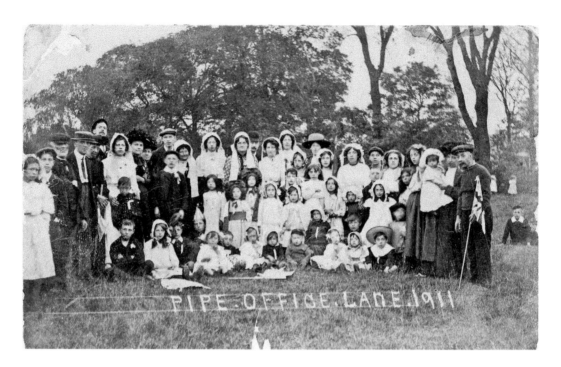

Pipe Office Lane

This little street once contained about thirty terraced houses and, given its central location between West Street and what is now the bus station, the old view looks surprisingly rural. The photograph was taken at the time of King George V's Coronation in 1911, when the whole neighbourhood seems to have turned out to celebrate on the field that was located beyond the houses at the bottom of the lane.

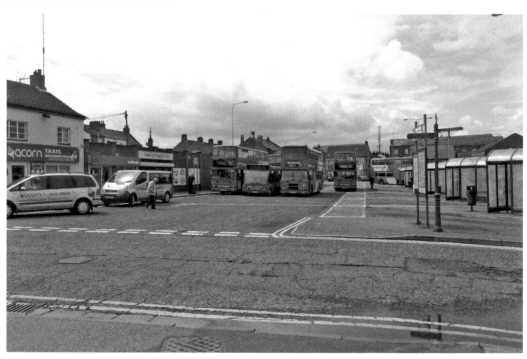

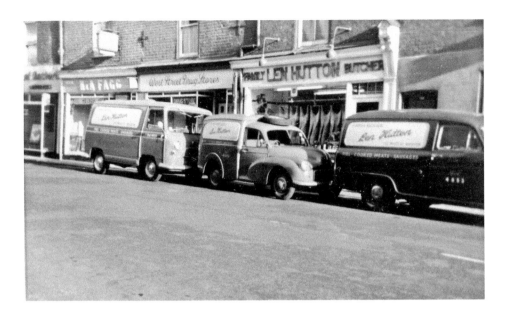

West Street

Further down West Street towards the railway station, Len Hutton's family butcher's shop was located in the building now occupied by a Polish grocery shop. Three neighbouring shops to the left have been converted into a Chinese restaurant. Some of the town's independent retailers have disappeared over the years as larger chain stores and supermarkets have moved into Boston and local people have changed their shopping habits, a situation that is unfortunately no different in Boston than in any other market town in England. The character of this end of West Street in particular has altered greatly in the last ten years or so with the arrival of a large number of new residents, many from central and eastern Europe, who have opened up small shops, delicatessens and restaurants, adding to the diversity of cuisine and cultural experiences.

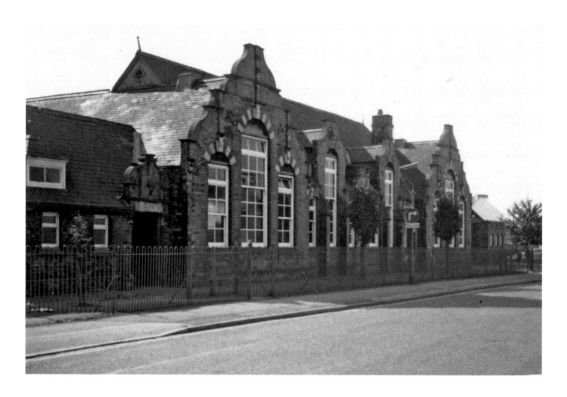

Staniland School

Staniland School was erected in the mid-1890s by the Boston School Board to replace the earlier St James' schools, which stood on the same site across the road from St James' church. The school was situated on the corner of Fydell Crescent and George Street, but following relocation to a new school building with playing fields on Peck Avenue, the old Victorian building was pulled down and the site, now used as a car park close to nearby West Street's shopping, restaurants and nightlife.

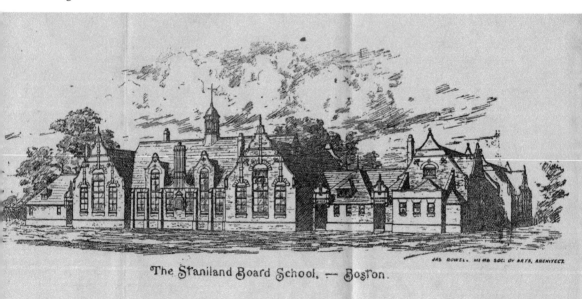

The Staniland Board School. — Boston.

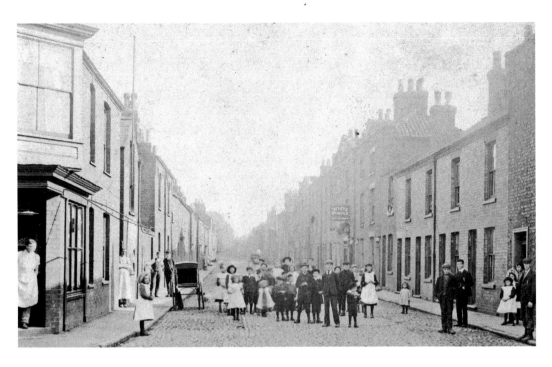

Liquorpond Street

While the shop and houses on the left are still standing, the street overall is very different indeed, as it now forms the main A52 trunk road. The children no longer have the chance to play in the streets, the grocer's on the corner, the houses on the other side, and 'The Little Wonder', a small shop selling sweets and cigarettes, are all long gone, which makes building a close community spirit very difficult.

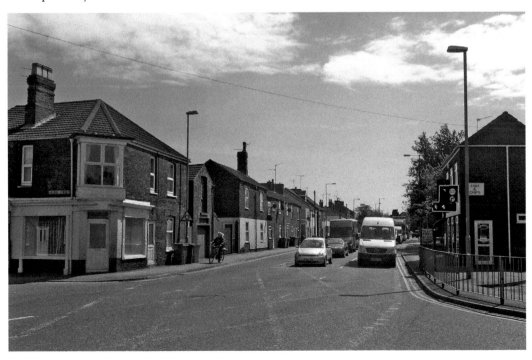

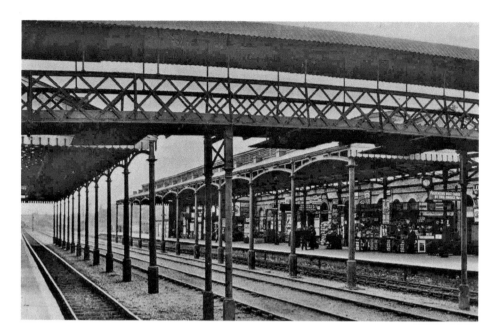

Boston Station, Looking North

The station in the Edwardian view is barely recognisable to anyone catching a train at Boston today. There was a newspaper and book stall on platform one, visible in the view above, and the canopy roof along each platform extended over the train, providing full protection from the elements. On platform two, the buildings have been demolished after decades of neglect, but they had originally housed the refreshment rooms. In its heyday, this was a very busy junction and large numbers of passengers would have made connections here. There were express services between Grimsby and London King's Cross, long distance services from the Midlands to the coast, and local services to Lincoln, Horncastle and Peterborough. Boston was hit hard by Beeching's cuts, and since 1970 has found itself merely a branch line station on the Nottingham to Skegness line, but it remains a staffed station functioning as a base for train crew and retaining an efficient and helpful booking and enquiry office.

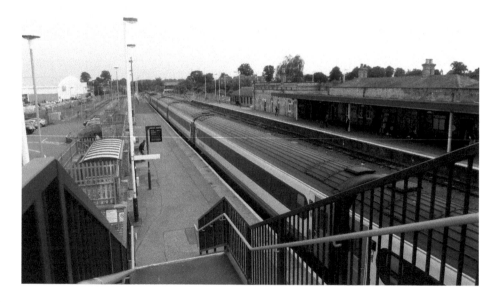

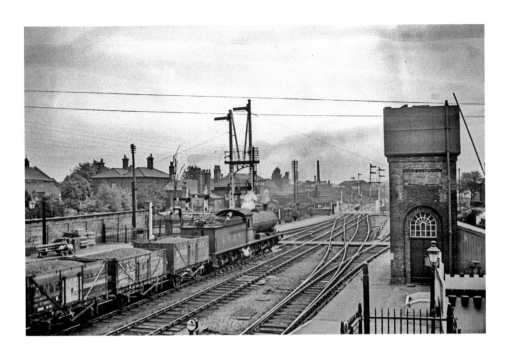

Boston Station, Looking South

The station has altered a great deal since the 1950s scene above. Gone are the centre 'fast' railway tracks and the corresponding high gantry signals, and gone is the water tower on the right – not needed of course with the replacement of steam with diesel trains – and gone is the little gatekeeper's hut to the left of the level crossing, itself modernised with barriers and warning lights. While the coal trains such as the one below and the fish trains are a distant memory now, the steam engine has not quite gone forever and at least once each year a rail tour hauled by steam calls at Boston station. Seen here is an ex-LMS locomotive No. 45699 named *Galatea* on 17 May 2014 on a Skegness to Scarborough tour.

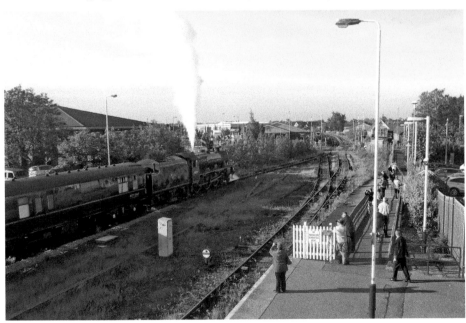

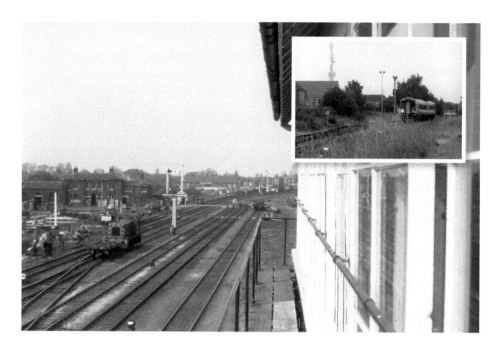

Broadfield Lane Crossing and Goods Yard, Looking North

The old view dates from the early 1970s, but already the railway scene has changed completely. The mainline between London and Grimsby was closed in 1970. The building on the left was originally the office of the Great Northern Railway's locomotive engineer in 1848, when Boston was the main headquarters for the GNR's locomotive engineers before it moved to Doncaster, taking around 700 jobs with it. The buildings were then used as the locomotive works for the Boston district, and it became known as the Broadfield Lane Depot. Many GNR railway buildings survived for new retail or industrial use, but this depot unfortunately did not survive and today there are attractive modern houses on this site and on the old goods sidings that ran to the east towards London Road. Trainloads of coal used to be brought here for export through Boston Docks.

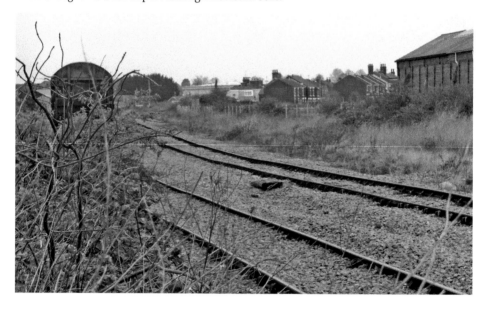

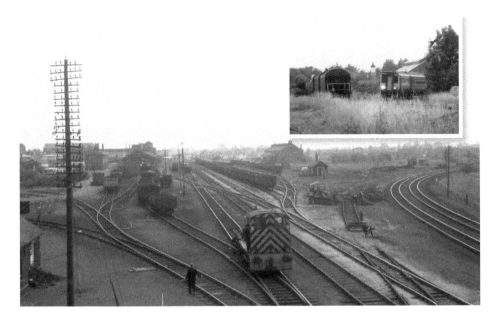

Goods Yard, Looking South

Here, the mainline to London is seen going off into the distance, but it had already closed to passenger traffic in this 1974 view. The line from Sleaford and the Midlands curves in from the right, and some of the newly abandoned track is being lifted. The building in the distance on the left was the goods shed, which still stands today, occupied by a number of small local firms, and the building on the right was the sacking store, which is now a retail store. At the present time, every single weekday evening, the steel train departs with steel coils that have come from Belgium, imported through Boston Docks. The Port of Boston own their own shunter engine and the wagons containing the steel coils are taken over the swingbridge that crosses the Haven to these sidings to await the locomotive that will bring in empty wagons and pick up the steel, taking it to Washwood Heath in Birmingham.

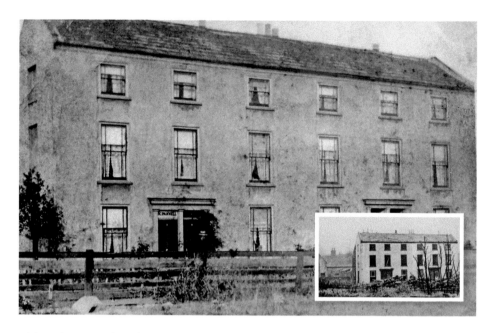

Oldman's Terrace/Middlecott Close

The three-storey Georgian houses that were known as Oldman's Terrace were located in Skirbeck Quarter, just off London Road near the level crossing, and faced the Boston to London mainline. In the photograph on the right, the end gable of Middlecott Almshouses is just visible. Thomas Middlecott lived in the seventeenth century and left land and money for the benefit of the poor. Today, both Oldman's Terrace and Middlecott Almshouses have been demolished, but the name Middlecott lives on in the name of the close on which the local authority built blocks of flats and bungalows were built to replace them. The railway line has also gone, axed in the Beeching cuts of 1970. After a number of years spent as a pleasant old trackbed footpath, they later had a new dual carriageway road built to take A16 traffic speedily along to Spalding and Peterborough.

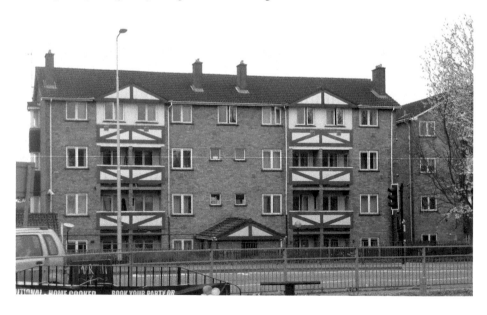

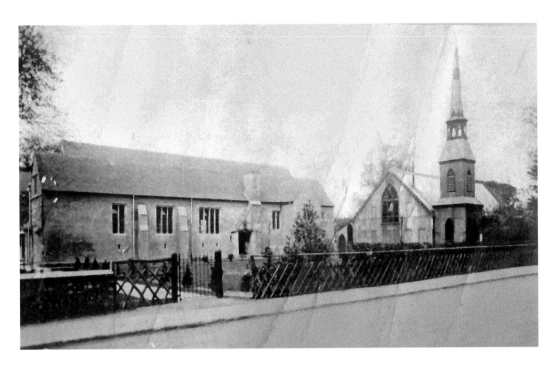

St Thomas' Church

St Thomas' is located in Skirbeck Quarter, which is to the south of Boston forming part of Skirbeck parish but separated by the Haven from the rest of Skirbeck. The church on the right in the above photograph was built of iron and erected in 1885, as before this time the parishioners had to make do with worshipping in St Thomas' School. Later, a new, more permanent structure was built, to the left of the iron building, which is the church that remains in use today.

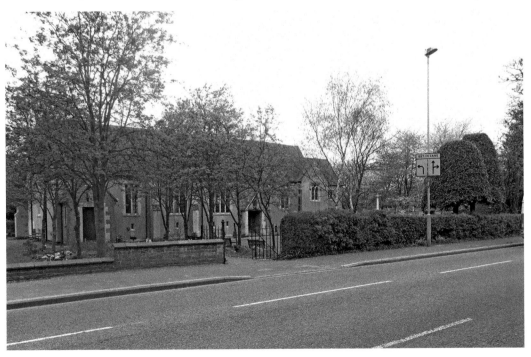

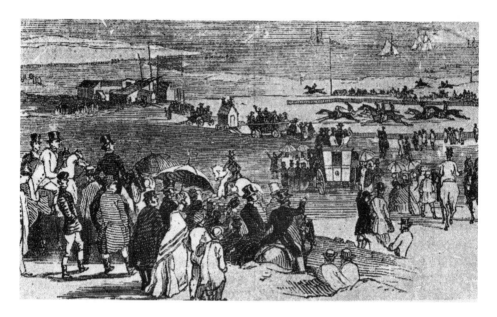

Freiston Shore

Freiston Shore was a busy resort in the nineteenth century, as this 1844 illustration by William Brand, the local customs officer, demonstrates. Not only locals flocked here, but also middle-class visitors from as far as Leicester. In those days, there was some sand here, although even within the living memory of the older generation today, there has only been mud and saltmarsh. The people came for the sea bathing and race meetings, and there was an annual sand fair, attracting around 6,000 people in August 1867. Today, the area is an RSPB Nature Reserve, which attracts a fair number of birdwatchers, but the biggest flocks today are made up of Avocets, Common Terns or Black-headed Gulls, rather than of people. The modern view below shows the more inaccessible muddy creeks, looking out to The Wash. Many acres of land have been reclaimed here and the shore is further out.

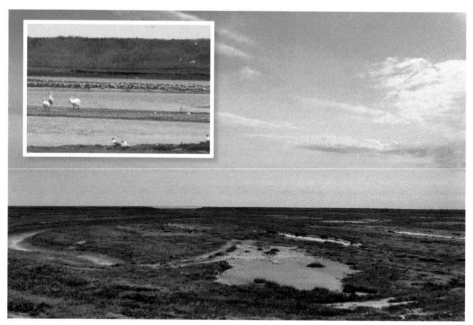

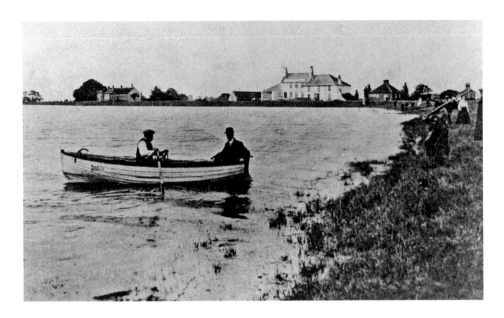

Freiston Shore

Throughout the twentieth century, Freiston Shore continued to provide a pleasant outing for townsfolk, especially for those who didn't always have the means to travel very far. At only 6 miles from the centre of Boston, it became the 'poor man's Skeggy', as people, including children, could cycle there and back. A great deal of fun and fresh air could be had, and there were two hotels here to provide refreshment. The Plummer's, situated on the left in these pictures, is still there but provides accommodation only, and the Marine Hotel, on the right is now a derelict shell of a building. However, Freiston Shore remains a beautiful, tranquil place to spend an afternoon. A flood defence scheme involved building an embankment to keep the seawater further back and creating a saltwater lagoon here, wich is a precious and rare type of habitat for wildlife.

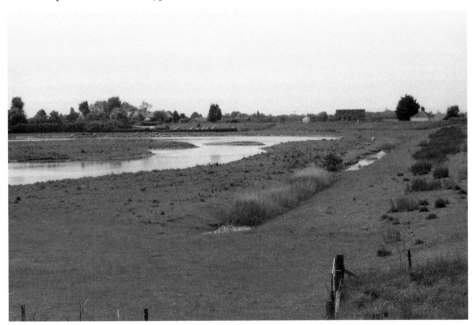

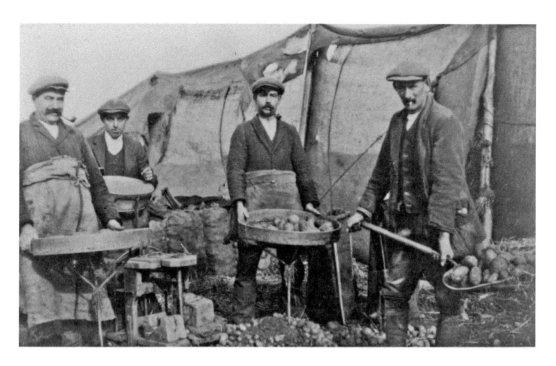

Potato Riddling, Leverton, Near Boston

In the past, it was common practice to bury surplus 'tairties' in 'graves', covered with straw, at the edge of the field at harvest time, so that later, in the cold wintertime or spring, they could be dug up again using a special shovel and 'riddled'. The process of riddling was to sort through the potatoes to check for any signs of disease or damage and then to grade them according to size, using sieves, before bagging them up into sacks. All this work was done in the outdoors by hard-working local men.

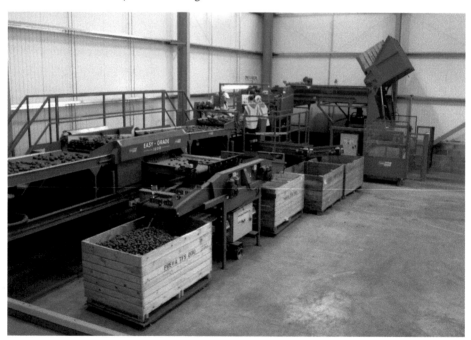

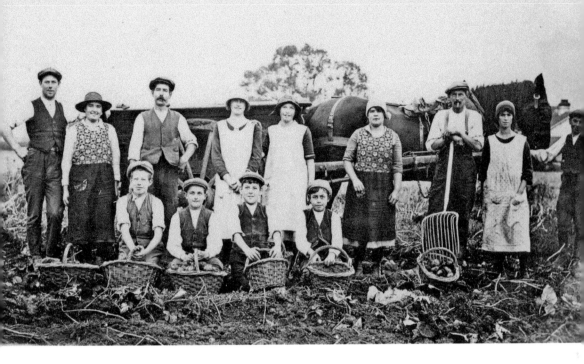

Potato Harvesting, Near Boston

When it was harvesting time, women and children helped provide the labour needed to get everything picked in time. They worked very hard, with only basic tools, for the little money they received. This group of local people from the Leverton and Leake area pose for a picture with the horse that will carry away the load of potatoes they had dug up and collected. Today, the work is highly mechanised, being much more capital intensive rather than labour-intensive.

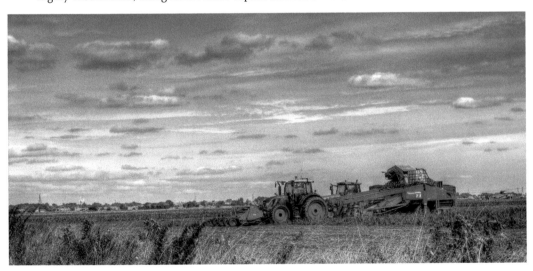

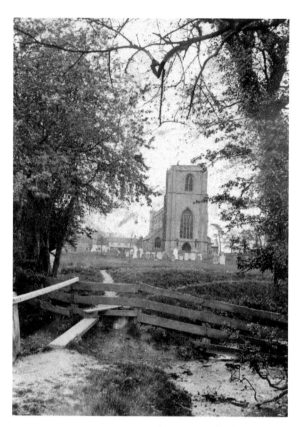

All Saints Church, Benington, Near Boston

Benington parish church dates back to around the year 1200, although parts of the building were rebuilt or added to later, with the tower built in the fifteenth century. It undoubtedly replaces an earlier building as the village is of Saxon origin. The path seen here, to the west of the church, has been improved following the building of Bede Crescent, a small, quiet and pleasant local authority built estate. The church was closed for worship in 2003, and the Benington Community Heritage Trust are working to reopen All Saints as the 'Beonna', which is a project that aims to restore the building and open it up for community, social and heritage functions.

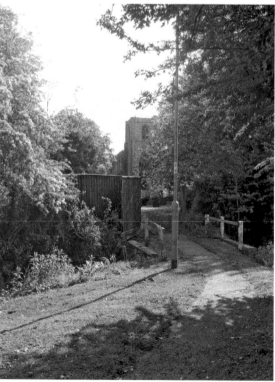

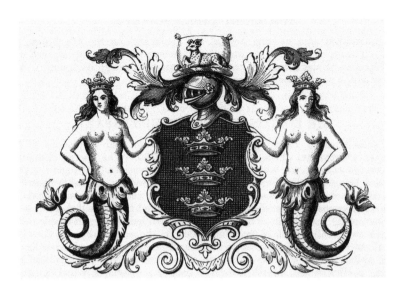

Boston's Civic Heraldry

The Arms of Boston date back to 1568. The associated motto was *Per mare et per terram* (by sea and by land). The woolpack and the ram signify the importance of the wool trade, the three crowns represent the feudal landowners – the Dukes of Brittany, Richmond and Suffolk – and the shield is supported by mermaids, just as the prosperity of the town has been supported by the sea through shipping and fishing. In 1974, with the reorganisation of local government the Boston Corporation and the Boston Rural District Council were merged, and the coat of arms used by the new Boston Borough Council was redesigned to reflect this. Blue and gold of the rural district replaced the original black and gold, and the wheatsheaf and the windmill sails were added, reflecting the Fenland agriculture and drainage. The woolpack and ram remains, but with the addition of a supporting lion, and the mermaids have lost their ducal crowns. The new motto (including the name of the River Witham) 'Serve with Amity' comes from the R. D. C.

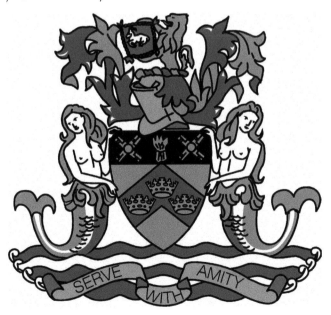

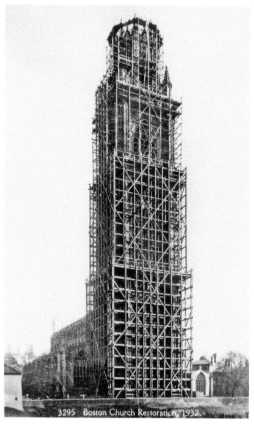

3295 Boston Church Restoration, 1932.

Boston

Where a town and its people are experiencing changes and challenges, the iconic Boston Stump provides a source of stability and pride and, throughout the ages, people from far and wide and closer to home, including royalty, have contributed to the funds needed to ensure this building is maintained and enhanced. St Botolph's church is fortunate to have two highly skilled full-time stonemasons. This building of cathedral proportions will no doubt witness many more changes as Boston continues to evolve in years to come.

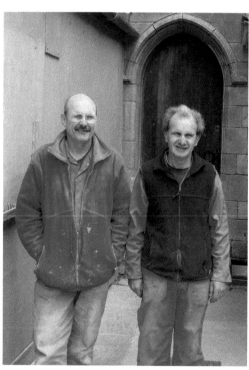

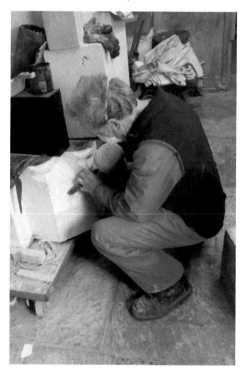

Acknowledgements

I would like to express my grateful thanks to everyone who has assisted by providing photographs or information, including readers of *The Boston Old Times*.

Special thanks go to Ernie Napier; harbourmaster of the Port of Boston Capt. Richard Walker; Capt. Henk Steenstra; Derek Paine; Tony Ayre; James Forinton; Arthur Garner; David Willis; Reflections of a Bygone Age and Eric Croft (author of *Boston on Old Postcards*); Derek Meeds; Carol Cammack; Alan Tosney; Paul Green; Ann Bainbridge; Steve Priestley; John Barrie; Wally Simpson; John Almond; Ted Walmsley; Geoffrey Dunham; Simon Lathlane; Bryan Graves; Theo and Wendy Van Noordt; Mike S. Shinn; David Enefer of davesrailpics; Richard Belton; Jonathan Wiltshire; the late Mr Billy Thorn, editor of the 'Boston Past Blogspot'; June Jay; Pete Massam, Jim S. Shinn, Hugh Pinner; Charles Tong of Tong Engineering Ltd of Ashby Road, Spilsby; and Boston Borough Council for permission to include the Borough Coat of Arms.

I would like to thank Emily Tinker, my editor at Amberley Publishing, for her assistance in producing this book.

Finally, I wish to thank my husband, Mike, and sons James, Alister, Aidan, Harvey and Michael for their support while I worked on this project.

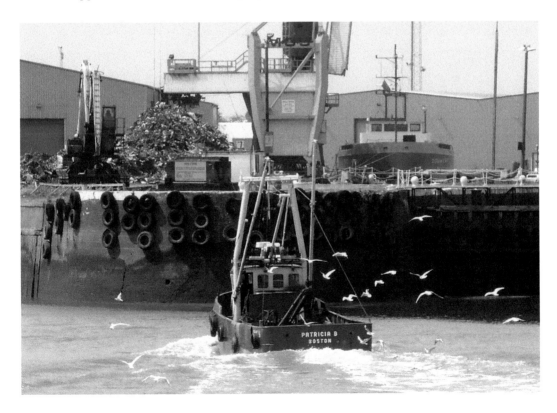

King's Lynn Through Time
Paul Richards

This fascinating selection of photographs traces some of the many
ways in which King's Lynn has changed and developed over the last
century.

978 1 4456 0837 2
96 pages, full colour